THE FIELD GUIDE TO
PHOTOGRAPHING

LANDSCAPES

CENTER FOR NATURE
PHOTOGRAPHY SERIES

ALLEN ROKACH
AND
ANNE MILLMAN

AMPHOTO
AN IMPRINT OF WATSON-GUPTILL
PUBLICATIONS/NEW YORK

To NOAH and ILANA, for the pleasure

of your company during our treks

across the American landscape

PICTURE INFORMATION:
Page 1. Meadow. Colorado.
Pages 2-3. Cathedral Rock. Sedona, Arizona.
Page 5. Denali National Park. Alaska.
Page 6. Bryce Canyon National Park. Utah.

Senior Editor: Robin Simmen
Editor: Liz Harvey
Designer: Bob Fillie, Graphiti Graphics
Graphic-production Manager: Hector Campbell

Text by Allen Rokach and Anne Millman
Photographs by Allen Rokach

Copyright © 1995 by Allen Rokach and Anne Millman
First published 1995 in New York by Amphoto,
an imprint of Watson-Guptill Publications,
a division of BPI Communications,
1515 Broadway, New York, NY 10036

Library of Congress Cataloging in Publication Data
Rokach, Allen.
 The field guide to photographing landscapes/by Allen Rokach
and Anne Millman.
 p. cm. — (Center for Nature Photography series)
 Includes index.
 ISBN 0-8174-3871-8
 1. Landscape photography. I. Millman, Anne. II. Title.
III. Series: Rokach, Allen. Center for Nature Photography series.
TR660.R69 1995 94-36840
778.9'36—dc20 CIP

Manufactured in Singapore

2 3 4 5 6 7 8 9/03 02 01 00 99 98 97 96 95

ACKNOWLEDGMENTS:

Many people contributed to the
making of this book. Once again,
we thank Mary Suffudy for her
confidence and for encouraging us to
launch this series of books. And again
we thank Liz Harvey for being a
patient and thorough editor.

 Special thanks to Howard and
Cheryl Feit for developing our love
of the outdoors and bringing us into
new wilderness locations; and to
Frank Kecko and David Ferguson, for
sharing good times, good meals, and
good humor during our trips togeth-
er. And an extra measure of gratitude
to Susan Amlung, Zvi Galil, Dana
Lehrman, Neil Rosenfeld, Cathy
Schwartz, Bert Shanas, and Tony
Stavola for their steadfast friendship
and support.

 Finally, we thank Kay Wheeler
and Sidney Stern for assistance in
keeping the photography studio run-
ning smoothly, so that we could
focus on this project.

Contents

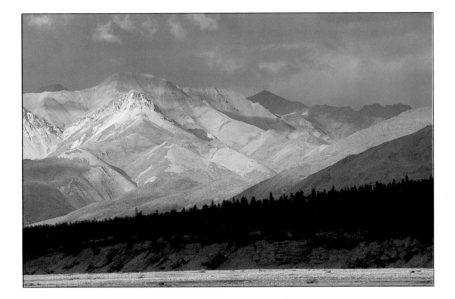

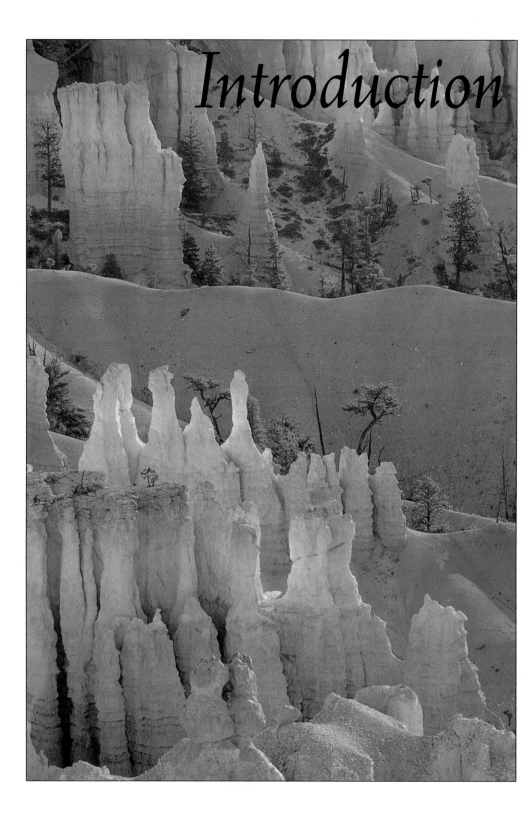

Introduction

When we thought about how this book began, we realized how long ago our journey started. For Allen, the source traces back to his college and graduate-school years, when his geology studies took him on field trips well beyond the confines he experienced growing up in a typically urban Brooklyn neighborhood. Those excursions awakened a love of the outdoors and a fascination with looking, in his case searching for clues to earth's long history. Not surprisingly, he decided to make a career of geology and first picked up a camera to document his findings for lectures and articles he was preparing. As an added bonus, Allen's geology colleagues fused into a band of "unforgettable characters" who regularly got together to conquer wilderness areas around the country, to enjoy the land and the great outdoors, be youthfully outrageous, and accomplish some male bonding. Only much later did Allen turn to photography as a full-time pursuit.

My own initiation into the joys of nature came at a much younger age in post-war Europe. My parents and I were refugees living in Germany, but the fact that they had survived an unimaginable ordeal and that they had a young child to raise made them embrace life and nature with special energy. To them, a day without a walk outdoors wasn't complete, and a weekend without an excursion to the park or the countryside was unthinkable. Even at three and four years of age, I remember the intensity of hikes into the Bavarian Alps. And when we were relaxing on a blanket in the sunshine, I was thrilled to watch my father work his artistic magic, recreating the magnificent scenery in his quickly sketched watercolors. Those simple paintings made a connection for me, between experiencing the landscape and recording its image.

Years later, when Allen and I crossed paths, we knew that a love of nature was a bond that we shared. Each of us had expanded our interest through travels around the world. Not surprisingly, we had been to many of the same places and wanted to go to many more. That started a collaboration that has taken many paths. One of our first joint assignments as a writer-photographer team was an article for *Science Digest* on how sand dunes migrate across the terrain. To get the shots, Allen and I drove cross-country to visit Colorado's Great Sand Dunes. We quickly realized that working together strengthened our individual skills. As a writer, I saw what caught Allen's trained eye, and that led me to ask questions I might not have thought to ask and enabled me to get the answers while we were still on location. As a result, I could write with greater insight and immediacy. At the same time, Allen became aware of aspects of the landscape that I noticed, especially features that filled important gaps in the visual narrative or editorial content of our piece.

That same sort of teamwork continued as we began organizing workshops for the Center for Nature Photography, which we launched 10 years ago. Together and separately, we concentrated on finding locations that would expose students to a variety of landscapes with opportunities for every kind of nature photography. Our only restriction was that the site have access to overnight film processing, so that we could conduct the daily critique sessions that are our hallmark and that make such a difference in the learning process. As we interacted with participating students, we honed our instructional program and built it around a combination of creative encouragement and technical guidance. The essence of those workshop lessons has been distilled into this book. It isn't quite the same as going into the field with us, but we hope that it brings you the kind of information that is both enlightening and inspiring.

ANNE MILLMAN

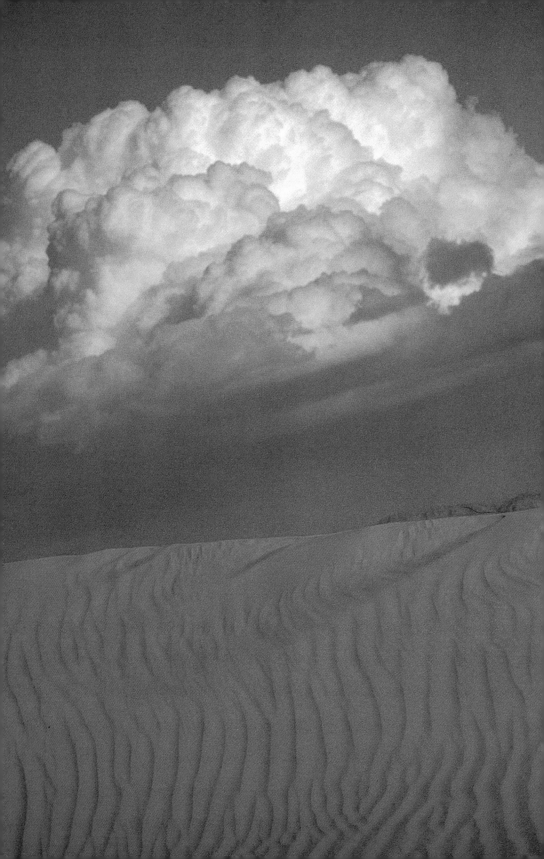

Interpreting the Landscape

On a windy day at Death Valley National Monument, low-lying clouds continually drifted over the dunes. I was captivated by the possibility of combining the ridge of a dune with this particular cloud because they seemed so different in texture and shape, yet so compatible. Using my Nikkor 200mm telephoto lens on my Nikon F2 camera, I created this tight, nearly flat composition. Shooting Kodachrome 25 for 1/125 sec. at f/8, I exposed at one stop below the meter reading in order to saturate the color of the sand and deepen the blue of the sky.

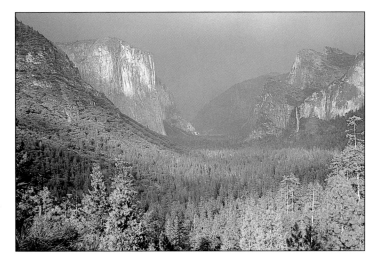

While I was walking along a trail in California's Yosemite National Park, thunderclouds began to gather over the majestic glacial valley below, and shafts of bright sun filtered through the clouds. Although everyone around me raced to their cars, I ran to a nearby pullout for an unobstructed view, grabbing a tripod and an umbrella on the way. Determining the exposure off the neutral-gray clouds was easy. With my Olympus OM-4T camera and my Zuiko 35mm wide-angle lens, I exposed Kodachrome 64 for 1/30 sec. at f/11.

G reat landscape photographs don't just happen. They're shaped by the combination of raw natural material, superior photographic vision, and refined technical skill. Learning to judge the raw materials critically is the first step. What does the landscape look like? What is its form, shape, texture, color? What is the impact of light on the subject? Do you want to represent the relationship of the specific landform to its environment? What is the best exposure based on the subject's colors and the available light?

The sun hadn't risen yet when I reached this viewpoint in Monument Valley. As an experiment, I decided to take a few "shots in the dark." I metered the brightest area on the land and made several exposures at various shutter speeds, up to 2 minutes long. I wasn't sure exactly what the results would be, but I expected that the colors of the land and sky could be eerily different from what most visitors see at this natural area. Shooting with my Olympus OM-3 and my Zuiko 18mm wide-angle lens, I exposed for 4 sec. at f/4 on Fujichrome 100 RD film.

Such questions help you evaluate a subject, so that you can develop a clear mental picture of the image you want to create. Without this previsualized image, which is the essence of photographic vision, you'll have a hard time deciding which pieces of equipment and which techniques to use. In order to become a proficient landscape photographer, you must interpret the landscape that your eye sees. You must learn to create in your mind's eye the image that your camera, lens, and film can make out of the basic elements of the scene.

RECOGNIZING A SCENE'S VISUAL POTENTIAL

How often have you stood before a breathtaking scene, utterly awestruck by its beauty? And how often have your attempts to capture it on film proven disappointing? "You had to be there," people say when they realize that their photographs haven't done justice to a great landscape.

Nevertheless, you've seen outstanding pictures of natural landscapes, images that make your heart beat a little faster or make you want to abandon everyday cares and head into the wilderness. What enables those photographers to record nature so brilliantly?

To begin your search for the answers to these questions, consider how successful photographers think about taking pictures. While most people respond to what they find visually appealing, personally inspiring, or simply beautiful, experienced photographers respond to something photogenic. To understand the notion of "photogenic," you have to translate what your eye sees into the language of photographic seeing. In other words, you must imagine the visual potential of the scene based on what your camera, lens, and film can do with it.

To be photogenic, the landscape must possess qualities that will record well on film. These qualities include evocative light, graphic lines and shapes, and definable colors. But these elements emerge only when the photographer's vision and technical skill work together. As amateur

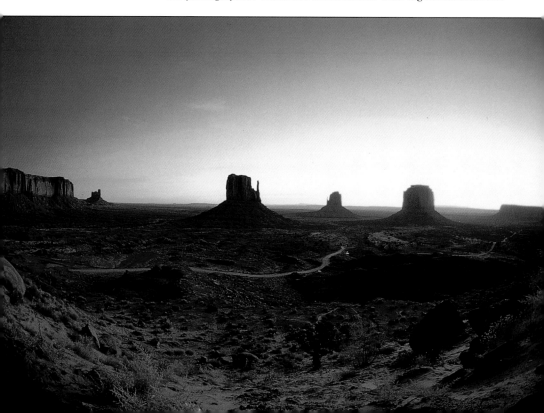

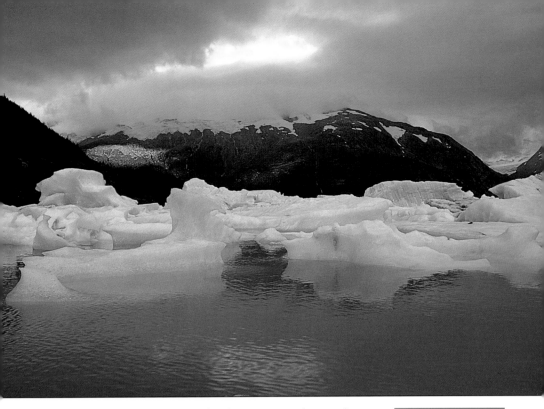

photographers become more astute, they learn to notice these qualities in scenes that most other people would pass by. The more you sensitize yourself to the special elements that make the landscape come to life, the more photographic opportunities you'll discover.

IDENTIFYING YOUR GOAL

Previsualization is the key to creating masterful landscape shots and other photographs of nature. Getting a clear mental image of the picture you want begins with identifying your purpose. Most photographers are so swept away by their emotions that they forget to identify their intentions. It pays to take a few moments to define what caught your eye and why you want to take a particular picture. Focusing your attention on what is most important to you will help you make smart decisions about composition, exposure, film, and other technical choices.

If you have trouble establishing your goal, try finishing the statement "What I want to show is. . . ." Complete this statement of purpose as precisely as you can. For example, you might say, "I want to document the structure and shape of these regal rock formations." In another setting, you might say, "I want to capture the repeating textures in the foreground grasses and the background trees" or "I want to integrate the radiant colors of these flowers hugging the cliff that overlooks the sea."

Your purpose may be straightforward documentary photography: to portray the intricate ancient sedimentation patterns in a cross section of exposed rock, to capture the majesty of a glacial valley, or to reveal the radiance of a coastline at sunset. On the other hand, your purpose may be to create an impressionistic image. You may, for example, want to underscore the romantic mood of a river surrounded by fall foliage; to dramatize the surprising blues of glacial ice; or to create a powerful abstract image using the shapes and colors of the land, sky, and water.

What struck me when I saw this scene at the Portage Glacier in Alaska was its stark monochromatic effect. The ice, water, sky, and land seemed like a study in black, white, and gray. Then a small patch of sun shone through, turning a corner of the hill bright yellow. I knew that the light wouldn't last long, so I worked quickly with my Olympus IS-3 camera at its 28mm wide-angle setting. I enriched the colors by underexposing the scene one full stop. The exposure was 1/8 sec. at f/16 on Fujichrome Velvia.

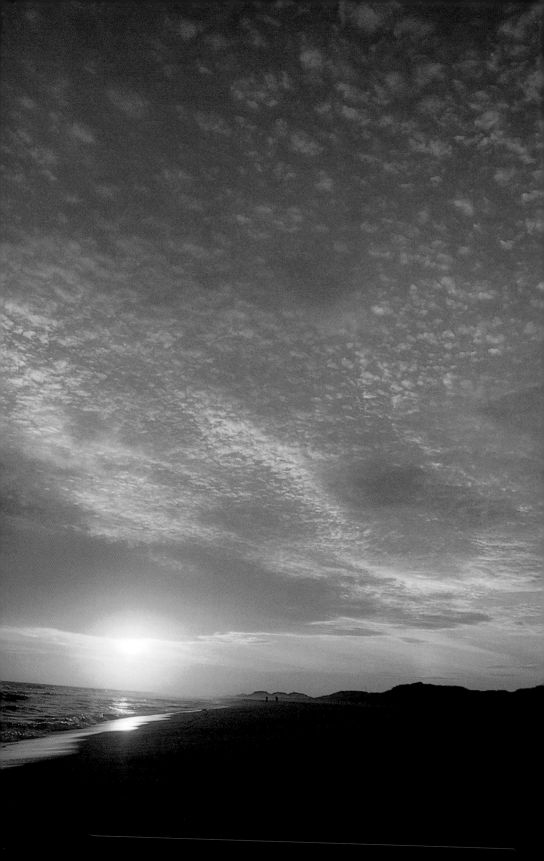

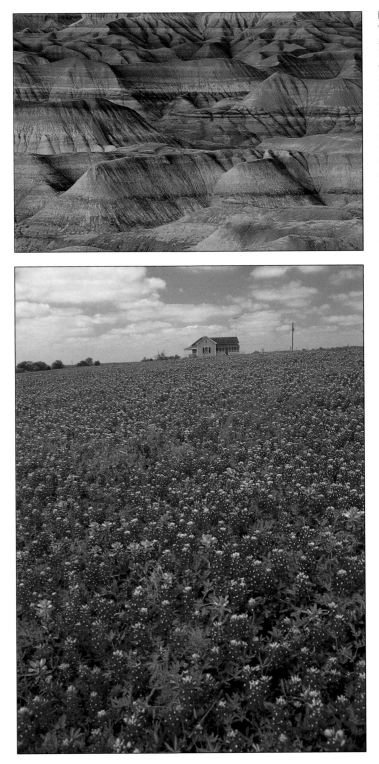

While photographing some sunsets at Fire Island in New York, I wanted to integrate the land, sea, and sky in a series of images. But a massive cloud cover had obstructed the sun completely. I stayed on the empty beach, knowing that the sun would dip below the clouds just before it set, and got into position at my chosen location. When the sun emerged, I quickly changed to my Zuiko 28mm wide-angle lens in order to show more of the sky in my composition. Then I metered the bright area of the clouds, not the sun or the dark land, to expose all the diverse elements without further underexposure. Shooting with my Olympus OM-2S and my Zuiko 28mm wide-angle lens, I exposed for 1/60 sec. at f/8 on Kodachrome 64.

These beautiful examples of erosion and sedimentation, which I came across in Arizona's Little Painted Desert State Park, demanded to be documented with clarity and sharpness. Working with my Olympus IS-3 at its 180mm telephoto setting, I exposed for 1/8 sec. at f/8 on Fujichrome 100 RD film.

This endless field of bluebonnets, dotted with Indian paintbrush, reminded me how vast the Texas countryside is. To stretch the foreground and increase the depth of field for maximum sharpness, I put my Zuiko 21mm wide-angle lens on my Olympus OM-4T. Shooting Kodachrome 25, I used a small aperture, f/16. I added an 82A blue filter to unify the blues in the sky and the flowers, which often look slightly purple.

After photographing at Point Reyes on California's Pacific coast around sunset, I realized that the coastal scene had great potential for some sunrise shots. When I arrived the next morning it was still dark, but I started to shoot the landscape just to capture its rich colors. As the sun rose, a distant sandbar appeared as a black band cutting across the brilliant reds of the sky and water. Immediately, I knew my purpose: to create a powerful abstract image using the shapes and colors of the land, sky, and water. To saturate the colors and deepen the black, I metered the mist on the background mountains and underexposed one f-stop from the reading. With my Olympus OM-4T camera and my Zuiko 50–250mm zoom lens, I exposed this shot on Fujichrome Velvia for 1/15 second at f/6.

Every photographer's goal is valid and highly individual. At our workshops, students shooting a subject and standing just several feet apart routinely produce completely different images primarily because they envision the possibilities in their own unique way. This is why one of our 10 commandments of nature photography says, "Express yourself: the joy of photography comes from the ability to project a unique vision that you can share with others."

Once you have a good idea of the image you want to create, you are ready to analyze the technical choices that will help you achieve it. And before you shoot, you must ruthlessly and scrupulously follow another of our 10 commandments: "Less is more: include only what is necessary in each frame; eliminate anything extraneous." Strip away whatever doesn't serve your purpose, and incorporate only what contributes effectively to the final image.

SHARPENING YOUR TECHNICAL SKILLS

While every truly inspiring landscape shot begins with a photographic vision, it takes good technique to consistently translate your mental images into magnificent pictures. Honing your technical skills starts by understanding which aspects of the photographic process you can control. Once you determine this, your photographic efforts depend less on luck than on a developing ability to select the right settings or tools to help you achieve the specific result you have in mind. The most important technical options for landscape photographers are exposure; sharpness; and the choice of lenses, filters, and film. You need to weigh these carefully each time you try to record the natural landscape.

One of the most difficult challenges in landscape photography is letting just the right amount of light to reach the film. The trick is to choose the best combination of camera settings—shutter speed and aperture—for the illumination you need. A camera's aperture settings, or

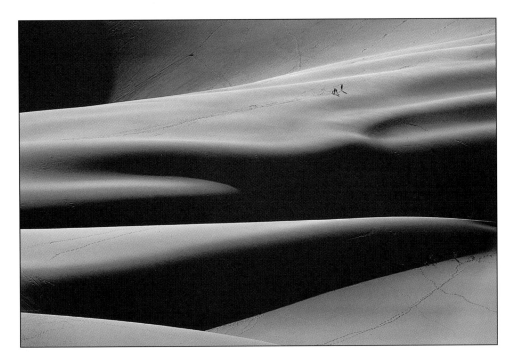

ƒ-stops, control the size of the diaphragm, which controls light intake and depth of field. The shutter-speed settings control light intake and the effects of motion. If shooting conditions remain constant, the slower the shutter speed, the more light enters the camera, and the greater the effects of motion in the scene.

Ideally, you want to determine an exposure that enhances the natural light and colors in the landscape. The greater the amount of contrast between light and shadow areas or between pale and dark colors, the harder it will be for you to perfectly expose the entire scene. Furthermore, it takes time to precisely analyze the available light and to handle variations in the illumination when you shoot. To be on the safe side, professional photographers always bracket from their prime exposure settings, under- and overexposing from the original meter reading in the direction that will produce the desired effect.

You'll have quite a few choices here because the shutter-speed and aperture work reciprocally together to let in the same amount of light no matter what the settings are. For example, the amount of light entering the camera lens will be identical whether you shoot at ƒ/11 for 1/125 sec., ƒ/16 for 1/60 sec., or ƒ/22 for 1/30 sec. Complicating this exposure determination even more is that these two controls also play important roles in determining overall image sharpness. The aperture setting dictates depth of field, and the shutter-speed setting affects whether movement in the scene records as a blur.

In general, landscape photographers want the sharpest images possible. Several technical factors influence sharpness. The main one, of course, is an unsteady hand. Fortunately, the solution is simple: use a tripod at all times. Next, you should learn to focus with precision on the most important element in the frame. With most 35mm single-lens-reflex (SLR) cameras, you can see exactly what is in focus in the scene through the viewfinder. All cameras, however, have a mechanism that brings—

I had to shoot from a high, distant vantage point to reveal how massive Colorado's Great Sand Dunes are. Once I found the ideal location, I chose my Nikkor 200mm telephoto lens to home in on a particular section of the dunes; I knew that the hikers there would give the image scale. Then I looked carefully to create a graphic design using the play of late-day shadows. I used my Nikon F2 and exposed for 1/15 sec. at ƒ/8 on Kodachrome 64.

either manually or automatically—a particular point in the viewfinder into the sharpest focus.

As mentioned earlier, aperture and shutter speed affect image sharpness. A small aperture, such as ƒ/16 or ƒ/22, maximizes depth of field. If this forces you to use a slow shutter speed, any movements in the scene may register as blurs. As a result, before you choose an aperture/shutter-speed combination, you should keep your goal in mind. You may have to compromise, sacrificing some depth of field or accepting some blurs (see Chapter 4 for more information).

Next, you need to think about lenses. People see the world from the same perspective all the time, while a camera's interchangeable and/or zoom lens enable you to alter perspective easily. All lenses have their place in landscape photography, even the 50mm standard lens. But certain types of images can be created with only specific lenses. For example, a wide-angle lens broadens your perspective, so you can record a wide span of the scene, even when you shoot at close range. This "stretching" of space enables you to combine a nearby subject with a panoramic background. A telephoto lens, on the other hand, brings distant subjects closer, so you can isolate a single landform. This lens also lets you compress the space between near and far subjects.

If you aren't familiar with the effects of various lenses, experiment with someone else's gear. Then when you are ready to shoot, choose the lens that will permit you to achieve your previsualized image best. You can also control the outcome of your images by selecting films and filters that subtly alter the ways colors are recorded (see Chapter 2).

PREPARING TO SHOOT

If you believe television commercials, you probably think that all photographers shoot fast and furiously, snapping away at anything and everything that appears in front of their viewfinders. This may be how sports and fashion photographers and even some photojournalists work, where the subjects are continually on the move. But this approach is completely counterproductive in landscape photography.

Except for rare occasions when a special lighting effect may last only a few moments, such as a rainbow after a storm, making successful landscape photographs is a slow, methodical process. Furthermore, it requires a great deal of concentration, determination, and patience. Fortunately, landscapes don't run away. Resist any tendency you may have to rush a photograph. The scenery may excite you, but your job is to think through the minutest detail of your composition before you shoot. Careful planning beats luck or chance in the long run. In fact, your preparation may even start by your anticipating being in the right place at the right time. This step is something serious landscape photographers do as a matter of course.

Suppose that you've found your desired location, clarified your mental image, and made all of the necessary technical decisions. While you may think that you are ready to press the shutter-release button, you actually should take another few moments to make sure that everything in the image is just so. First, study the subject thoroughly. Ask yourself the following questions. Have you included too much foreground? Is the balance between the land and the sky right? Are you shooting from a promising viewpoint? Be sure to move around, try different lenses, as well as both horizontal and vertical formats.

Next, you should play to the image's strengths. If the best features in a particular landscape are small and insignificant, the final photograph will suffer. Be sure to give the most beautiful or significant aspect of your

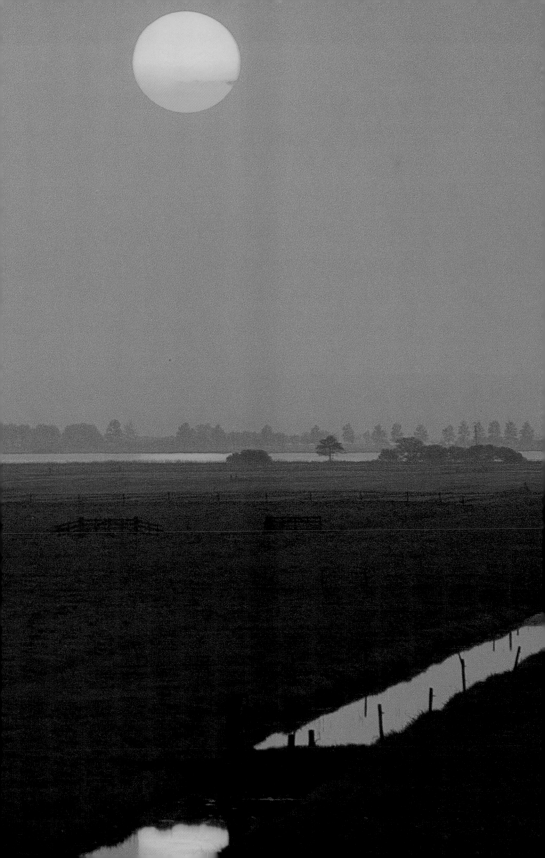

subject visual prominence by moving closer, zooming in, or changing your perspective. You should also observe the flow of lines, shapes, colors, or textures and emphasize the strongest elements. Use any interplay of light and shadow for theatrical value.

Another important part of making a successful landscape shot is editing in the camera. Train yourself to look across the entire plane of the film frame. Carefully scan along the edges and into the corners. Be as objective as your camera is. Recognize potential distractions in the scene, such as wires, signs, or bright spots of light, and eliminate them. If the sky is dull, tip your camera down or use a filter to improve its color. Include only what you want in the final photograph, and eliminate all unnecessary, distracting elements.

Finally, keep in mind that professional photographers would never dream of taking only one shot of each scene. This isn't simply a saturation technique that guarantees that if you take enough shots, some are bound to be good. The "never say done" approach is a matter of working tirelessly to improve each composition. The best photographers aren't satisfied until they've tried every possibility.

PUSHING YOUR CREATIVE LIMITS

It is one thing to bring a unique perspective to a subject and another to see only limited possibilities or to photograph it the same way each time. One is a vision; the other is a rut. How can you keep taking pictures of the landscape with a fresh eye and a keen imagination? One way to shake up your creative potential is to study the landscape images of master photographers and painters. See how they look at the land, not simply to copy them, but to learn how they manage to avoid visual clichés. Another approach is to change the way you look at the landscape. If you tend to shoot from eye level, get low to the ground or climb to a high vantage point. If you favor a particular lens, put that lens away and select another. If you're used to shooting from afar, force yourself to move closer to your subject. If you take pictures only in the middle of the day, discover a new world at dawn or dusk. And if you ordinarily photograph on sunny days, see what a difference a change in weather conditions can have on your photography.

If you've tried all of these alternatives and are ready for even more options, give yourself assignments that push your creative limits. For example, see how many new images you can come up with by shooting in only backlighting or with only a telephoto lens. You can also go back to a specific location at various times of the day or year to find out if the change in the landscape inspires you to stretch your imagination. By confronting—or concocting—new challenges, you'll extend your imagination's boundaries and undoubtedly, you'll create images you never thought possible.

Early-morning illumination creates natural colors that can be seen only at this time of day. To arrive at this favorite spot on the coast of Maine just before sunrise, I got up at 4 A.M. Since I knew exactly the composition I wanted, I'd mounted my Olympus OM-4T and my Zuiko 35mm wide-angle lens on a tripod. The instant the sun came over the horizon, I started shooting and got this image. The exposure was 1 sec. at f/16 on Fujichrome 100 RD film.

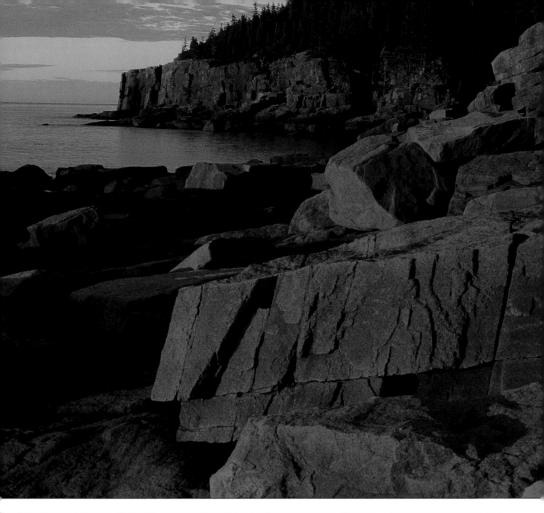

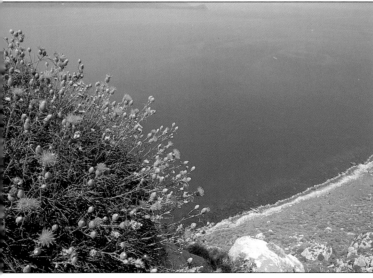

As soon as I saw this flow-
ering bush on the cliff side
of a Greek island, I saw
an image in the making. I
felt that the calm blue sea
would provide an unusual
background for the con-
trasting textures and colors
of the shrub. In addition,
the curving coastline below
would add just the right
organizing design element.
My Zuiko 28mm wide-
angle lens enabled me to
frame the shot from a dis-
tance of less than 2 feet.
With my Olympus OM-4T,
I exposed at f/11 for
1/125 sec. on Fujichrome
100 RD film.

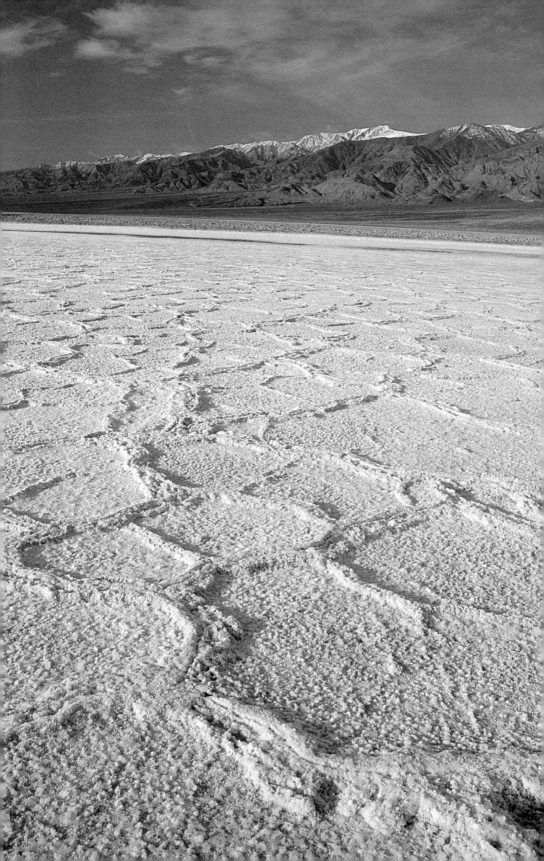

CHAPTER 2

Gearing Up

I made this photograph with my Zuiko 21mm wide-angle lens to integrate the foreground and background. Shooting in Death Valley, California, with my Olympus OM-4T, I exposed Fujichrome Velvia at f/16 for 1/125 sec.

Here, I used my Olympus OM-4T and my Zuiko 180mm telephoto lens in order to isolate the trees in the reflection in a river in South Carolina. For this impressionistic shot, I exposed Fujichrome 100 RD film for 1/250 sec. at f/2.8.

Y ou can shoot landscape photographs with a minimum of specialized equipment more readily than you can shoot any other kind of nature photographs. Having a clear vision and being able to put together a coherent composition are the marks of great landscape images. These depend more on photographers' inner resources than on their financial resources. Still, you need to get some essentials and, not surprisingly, these can expand as your specific interests develop. Your most important consideration should be the quality of the equipment you buy. As a rule, you are better off investing in the best of a few items than a bag full of lesser gear.

CAMERAS

First on your list should be a camera, and you have a number of excellent options to choose from. Some of the greatest landscape photographers in the past worked with large-format cameras, either out of necessity or by choice. Today, quite a few photographers continue to use large-format cameras. The most common large-format view cameras produce 4 x 5-inch and 8 x 10-inch transparencies. Medium-format cameras are also available from Fuji, Hasselblad, and Mamiya; these models shoot 2 1/4 x 2 1/4-inch or 6 x 7cm film.

Because the transparencies, or negatives, that large-format cameras produce are so big, the resulting images can be especially sharp and rich in detail. In addition, large-format cameras enable you to swing, twist, and tilt the lens and film planes, thereby giving you extensive control over focus, depth of field, and perspective. However, large-format cameras are bulky and slow to operate, and take some getting used to since you view the image upside down and backwards when you compose.

Of course, the camera most serious photographers and professionals use today is the 35mm single-lens-reflex (SLR) camera. This isn't surprising when you consider its advantages over the competition. This camera offers through-the-lens (TTL) viewing, so you actually see the image you'll record. You also have complete control over aperture and shutter-speed settings, which is important in sophisticated photography. Some newer models, such as the Olympus IS-3 and the Nikon N-90, offer a program mode with a landscape setting that automatically produces the most extensive depth of field from foreground to background.

SLR cameras also have a diversity of interchangeable lenses, ranging from a 16mm ultrawide-angle lens to a 1000mm super-telephoto lens. In addition, 35mm SLR cameras accept the highest number of different films. Still another reason why these cameras are appropriate for landscape photography is that they are light, compact, and easy to use.

I came across this farm scene in Steamboat Springs, Colorado. The early-morning mist and low-angled sunlight revealed the color and texture of the grasses. I used my Olympus OM-4T and Zuiko 35mm wide-angle lens to capture this sprawling landscape. The exposure was 1/125 sec. at f/16 on Fujichrome Velvia.

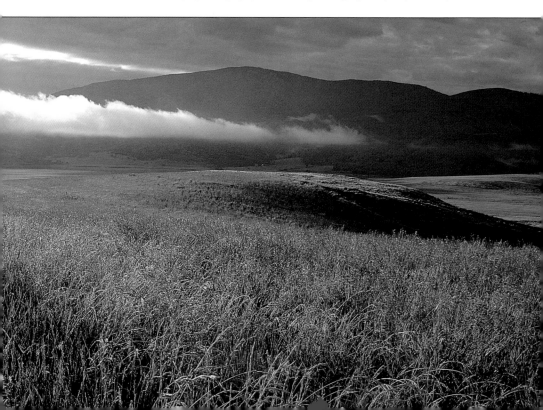

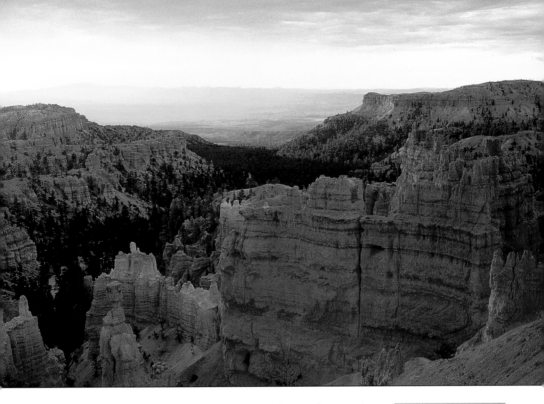

Point-and-shoot cameras also have a place in landscape photography; keep in mind, though, that it is limited because of their various built-in and automatic features. They are, however, simple to use, as well as smaller and lighter than SLRs, all of which makes them ideal for backpacking and other shooting situations when you want to carry and use the lightest gear possible. Nevertheless, the range of lens options on point-and-shoot cameras is much narrower than that for SLR cameras. You should also keep in mind that point-and-shoot cameras give you either little or no control over *f*-stops, shutter speeds, and focus, and that they don't offer TTL metering.

Closer to traditional 35mm SLR cameras than point-and-shoot models are the so-called "bridge" cameras. These include the Olympus IS-2 and the Olympus IS-10, which have a built-in zoom lens. You can expand their capacity with the wide-angle and telephoto screw-on lenses available on the market.

Naturally, another possibility for landscape photography is a panoramic camera. In recent years, interest in panoramic images has grown. You can make these photographs with very sophisticated electronic panoramic cameras that cost up to $15,000 and come in rotation and nonrotation models designed to record from 90 degrees to as much as 360 degrees. But unless you plan to shoot a large number of panoramic images, you don't need to invest in this type of camera. You can get similar effects with special adaptors for point-and-shoot cameras and with the disposable panoramic cameras Kodak and Fuji make. These are, respectively, the Panoramic 35 and the Stretch. Keep in mind, however, that these disposable cameras have plastic lenses and don't offer photographers any exposure control.

For general landscape photography, a 35mm SLR camera is your best choice. If you are in the market for a new camera, check recent issues of

The first light of morning bathed this rock formation in Bryce Canyon National Park, Utah, with a warm pink-orange glow. Shooting with my Olympus IS-3 at its 50mm standard setting, I exposed Fujichrome Velvia at *f*/11 for 1/60 sec.

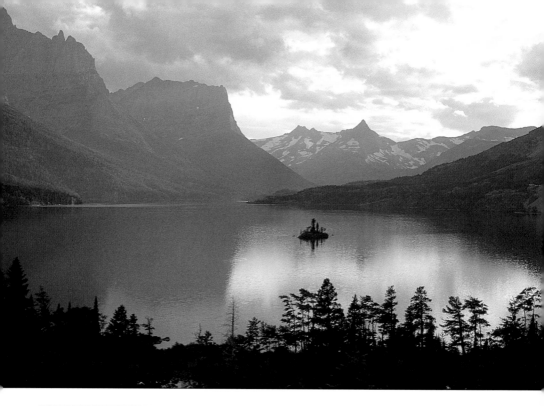

I made this moody shot of Glacier National Park, Montana, with my Olympus OM-4T and my Zuiko 35mm wide-angle lens. The overcast skies transformed this mountain scene into a compelling combination of black, gray, and white. The exposure was 1/30 sec. at f/11 on Ektachrome 64 Professional EPX film.

A standard lens maintains the perspective of the human eye in vignettes, such as this intimate landscape shot in Montana's Glacier National Park. A polarizer removed the bright reflections of the midday sun on the surface of this pool and on the surrounding foliage. Using my Olympus OM-4T and my Zuiko 50mm standard lens, I exposed for 1/125 sec. at f/11 on Fujichrome 100.

photography magazines for the latest technical comparisons. Before you purchase a new camera, try out various models and select the one that best suits your needs—and your hands.

LENSES

Assuming that you'll use a 35mm SLR camera when shooting landscapes, you'll want to take advantage of an array of interchangeable lenses to expand the visual possibilities inherent in this kind of photography. But just because you have dozens of fine lenses to choose from, don't make the mistake of buying more than you truly need.

As you consider which lenses to purchase, remember that you'll often be taking landscape photographs in locations that require some walking or hiking to get to. This means that you'll have to carry your gear for some distance. Nothing dampens an individual's enthusiasm for taking pictures faster than having to lug heavy equipment around.

Also keep in mind that some of the greatest photographers worked with very limited equipment. French photographer Henri Cartier-Bresson used only a 50mm standard lens for all the marvelous images he made. Restricting your equipment can enhance both discipline and creativity. That said, chances are, nevertheless, that you'll want to bring a few lenses along. Give some careful thought to the following options for your landscape photography.

A 50mm standard lens is inexpensive and produces a perspective that most closely resembles what the unaided human eye sees. This lens is fine for moderate panoramic shots and for intimate landscapes or vignettes, which focus on a limited area. Although standard lenses can be fast, with maximum apertures as wide as f/1.2, you'll discover that lens speed isn't vital for landscape photography. This is because you'll usually mount your camera on a tripod when shooting.

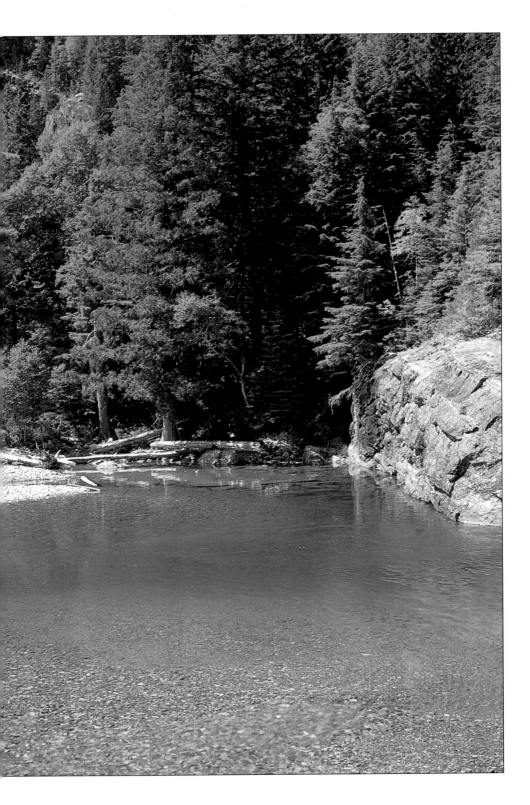

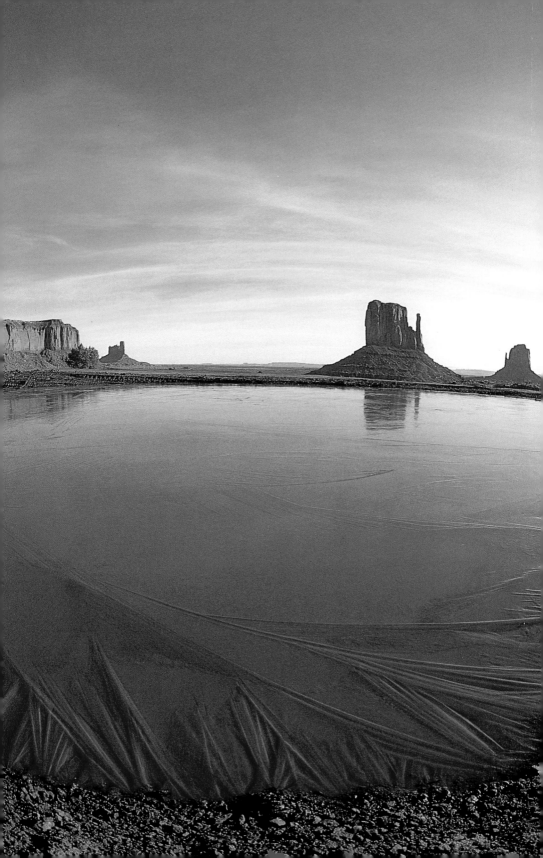

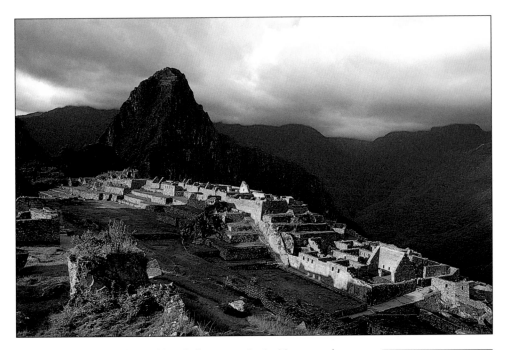

A standard lens is often sold with the camera body. However, if you plan to shoot closeups as well as landscapes, you might be better off with a macro lens in the 50mm-to-60mm range. Such a lens can perform the same way a standard lens does, but, in addition, it enables you to work at very close distances—within an inch of the subject—an advantage most nature photographers want to have.

Any lens with a perspective wider than 50mm is considered a wide-angle lens. For landscape photography, the most useful lenses range in focal length between 24mm and 38mm. Lenses with wider perspectives tend to distort the subject. The wider the angle of the lens, the more exaggerated the perspective will appear in the final image. Nonetheless, some photographers regard the fisheye effects that ultrawide-angle lenses can produce as interesting.

Since wide-angle lenses provide extensive depth of field, you can keep the entire field of view in sharp focus. This makes these lenses especially handy when you want to integrate foreground and background areas in a landscape. You can combine a nearby subject with the broad expanse of its setting with little or no loss of sharpness in either. For example, you can show wildflowers against their mountain backdrop or feature the ripples on a sand dune while the entire dune remains visible. Wide-angle lenses are also excellent for working in such narrow spaces as slot canyons and forest interiors, and for creating unusual perspectives, particularly close to the ground.

When you want to magnify a distant landscape subject or to isolate a portion of the landscape, you need to use a telephoto lens. Lenses with focal lengths between 80mm to 200mm are best for these landscape pictures, but some photographers use lenses up to 500mm long. The higher the magnification power of a lens, the heavier and bulkier it is likely to be—and the harder it will be for you to handle. And remember, you should always mount your camera on a tripod when using a telephoto lens in order to eliminate camera shake.

Here, my Zuiko 35mm wide-angle lens gave me just enough additional breadth to combine the ruins of Machu Picchu in Peru with the surrounding landscape. I made this shot with my Olympus OM-4T and exposed for 1/60 sec. at f/8 on Kodachrome 25.

I deliberately used the distortions typical of my Zuiko 18mm wide-angle lens to dramatize the relationship between this ice-encrusted puddle and the buttes of Arizona's Monument Valley. The puddle looked much larger than it was, thereby making its rust color prominent. The lens also pushed the surroundings back while integrating them in the composition. A polarizer reduced the reflections on the water and deepened the blue of the sky. Shooting with my Olympus OM-4T, I exposed for 1/15 sec. at f/16 on Fujichrome Velvia.

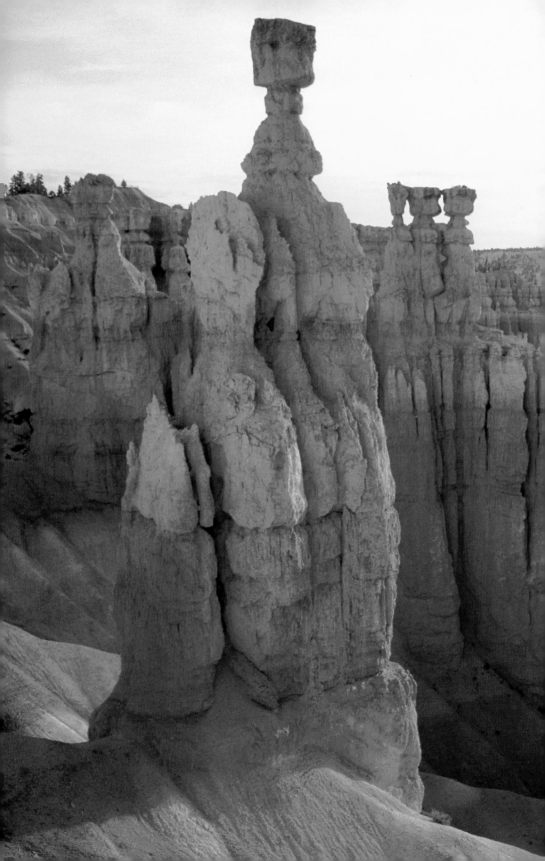

After experimenting with my Zuiko 35–70mm zoom lens mounted on my Olympus OM-4T, I found that a standard perspective, around 50mm, let the foreground formation, known as Thor's Hammer, dominate this early-morning landscape image. Shooting in Utah's Bryce Canyon National Park, I exposed for 1/4 sec. at f/11 on Fujichrome Velvia.

To encompass the fore-ground fence and the background hills in this late-day, sidelit Colorado landscape, I used a wide-angle lens. This choice minimized the uninteresting sky. With my Olympus OM-4T and my Zuiko 28mm wide-angle lens, I exposed Fujichrome 100 RD film for 1/15 sec. at f/16.

Because telephoto lenses telescope the landscape, flattening and compressing space, you can use them to visually juxtapose areas that are at some distance from one another. Many photographers seem unaware of this interesting effect. It works best when the subject has strong graphic qualities—simple shapes, lines, and colors—that contribute to the abstract design of your composition. For example, you can compress a series of mountain ridges for just such a juxtaposition. In addition, the narrow depth of field of telephoto lenses enables you to blur out foreground foliage in order to emphasize more distant subjects.

If you want flexibility in composing without having to change lenses too often, you can take advantage of the many new zoom lenses on the market. Choosing a few that serve your purpose also reduces the amount of equipment you'll need. For example, you can use a 35–70mm zoom lens for tight, intimate landscapes and a 65–200mm zoom lens for telephoto effects. When you hike and/or when your carrying space is limited, take along a wide-angle lens and a 50–250mm zoom lens. These lenses will maximize your shooting potential.

For each lens you own or plan to buy, be sure to add a lens shade in order to reduce glare and flare when you shoot outdoors. The wrong size lens shade may cause vignetting, a darkening at the corners of the frame where the lens shade is visible. You also need to look for possible vignetting whenever you use a wide-angle lens and when you mount a lens shade on a filter; this is particularly important when you use a polarizing filter, or polarizer.

Before you purchase a new lens, you should consult a recent issue of a reliable photography magazine, such as *Popular Photography*. Within its pages, you'll find essential information about the quality of the lenses on the market. Photography magazines run extensive tests and reproduce the results, so that readers are able to base their decisions on sound information.

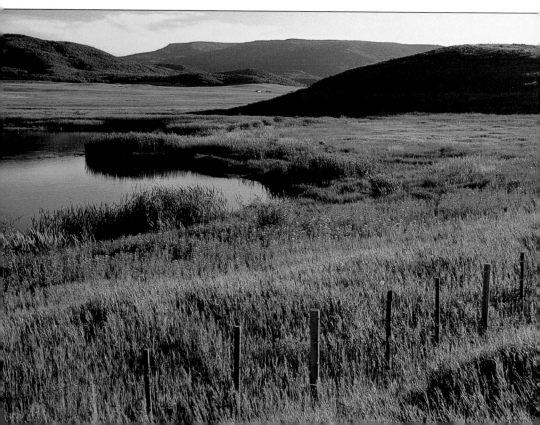

ACCESSORIES

With a camera body and the right lenses, you have the bare essentials for landscape photography literally in your camera bag. Next, you have to consider the features of the bag itself, as well as some other accessories that are fundamental to your photographic results or to your comfort and ease. A strong, sturdy, waterproof camera bag that has both zipper and snap-lock closures simplifies carrying and locating the equipment you need.

Keep the size comfortable enough to carry when fully loaded, with just enough space for two camera bodies, lenses, film, and other necessities. A bag that is too large may trap you into carrying too much equipment with you. Conversely, a bag that is too small will overflow, potentially resulting in damage to or the loss of your equipment.

If you plan to do a great deal of hiking in conjunction with your photography, think about buying a backpack camera-bag model or get an adaptor for your shoulder bag. The Lowepro AW line of camera bags has built-in, all-weather covers that can fully protect your gear from rain; this is a real bonus if you photograph in mountain regions or other locations where the weather is very changeable. Other helpful features include quick-connect buckles, velcro fasteners, wide straps, and tele-photo-lens compartments.

Next, you have to give some thought to purchasing a tripod. All landscape photographers know that a tripod is vital for keeping the camera absolutely still when you do this kind of photography. This piece of equipment ensures greater image sharpness, makes composing and bracketing easier, and lets you show your companions what you are up to. When several photographers shoot a scene together, they can look through each other's viewfinders to compare their compositions when their cameras are mounted on tripods.

I used a medium-telephoto lens to concentrate the green of this high meadow in the Colorado Rocky Mountains. Shooting with my Olympus OM-4T and Zuiko 100mm telephoto lens, I exposed for 1/30 sec. at f/16 on Fujichrome Velvia.

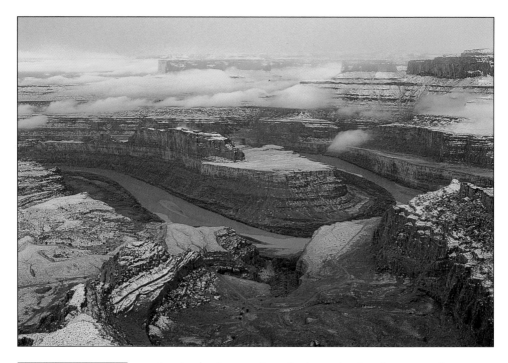

Here, I used my Minolta spot meter on the brown canyon walls of Utah's Dead Horse Point State Park to get a reading that would keep the clouds white. A general meter reading would have underexposed the scene, turning the clouds gray. I had to mount my Olympus OM-4T and my Zuiko 35–70mm zoom lens set at 35mm on a tripod to steady the setup in a strong wind. The exposure was 1/15 sec. at f/16 on Fujichrome Velvia.

A polarizer helped to saturate colors, eliminate reflections from the water, and deepen the color of the sky in this late-day landscape outside Steamboat Springs, Colorado. Working with my Olympus OM-4T and Zuiko 35mm wide-angle lens, I exposed Fujichrome 100 RD film for 1/30 sec. at f/11.

Landscape photographers also know that few things are as frustrating as trying to set up a tripod that is flimsy, won't stay in place, or can't accommodate very uneven terrain. That is why it pays to invest in a sturdy, stable, easy-to-use tripod with legs that can spread wide and that can be moved independently of each other. Since a good tripod can last a lifetime, be sure to buy the best one you can afford. When you shop for your tripod, take a look at the Bogen 3221 with its lever-tightening system or the Gitzo with its screw-tightening system. You'll find that both tripods are reliable, sturdy, and user-friendly.

As you make your decision, you also must be sure to choose a tripod with a solid ball-joint head. This feature will enable you to maneuver your camera to any angle with ease. Check out the Linhoff Prof. II, Bogen 3036, and Foba Superball tripods. If you still prefer the Bogen 3221 or the Gitzo, you should specifically request that its pan-tilt head be replaced with a solid ball-joint head. Whichever tripod you decide on, you'll need to add a cable release that is at least 12 inches long in order to complete the package.

Another useful accessory is a handheld spot meter. This device permits you to meter specific parts of the landscape with pinpoint accuracy, which is a real boon in high-contrast or variable-light conditions. A handheld spot meter also serves as a check or a backup to your camera's built-in light meter. The Minolta Spotmeter F and the Gossen Luna Star F are both excellent models. Don't confuse a spot meter with a handheld incident-light meter, which is quite useful for other types of photography but is only optional for landscape photography. An incident-light meter discounts extraneous illumination from bright reflections in high-contrast conditions, thereby providing a more accurate gauge of the entire scene than a spot meter does.

Many different filters are basically indispensable for landscape photography. The most useful of these is a polarizer. By rotating this filter on

An 81A warming filter enhanced the red glow of the setting sun on this Colorado landscape. I made this shot with my Olympus OM-4T and my Zuiko 35mm wide-angle lens, exposing Ektachrome 100 EPZ film for 1/8 sec. at f/16.

(Overleaf, top left) A tripod was essential to keep my camera and telephoto lens steady while I shot the salt flats at California's Death Valley National Monument. Working with my Nikon F2 and my Nikkor 24mm wide-angle lens, I exposed for 1/60 sec. at f/11 on Kodachrome 25.

(Overleaf, bottom left) I spot-metered the land, so the low-lying mist would stay white in this early-morning shot in Colorado's Rocky Mountains. A polarizer reduced the glare on the grasses in this backlit shot. With my Olympus OM-4T and my Zuiko 35–70 mm zoom lens set at 35mm, I exposed Fujichrome Velvia for 1/15 sec. at f/11.

(Overleaf, top right) To create this flat compression of the salt flats at California's Death Valley National Monument with my Olympus OM-4T and Zuiko 500mm telephoto lens, I had to use a sturdy tripod. I added an 82A cooling filter to accentuate the subtle blues in the composition. The exposure was 1/60 sec. at f/8 on Fujichrome Velvia.

(Overleaf, bottom right) A split ND filter equalized the contrast between the brightly illuminated walls of Arizona's Canyon de Chelly National Park and the deep shadow on the river below. With my Olympus OM-4T and my Zuiko 35mm wide-angle lens, I exposed at f/16 on Fujichrome 100 RD film.

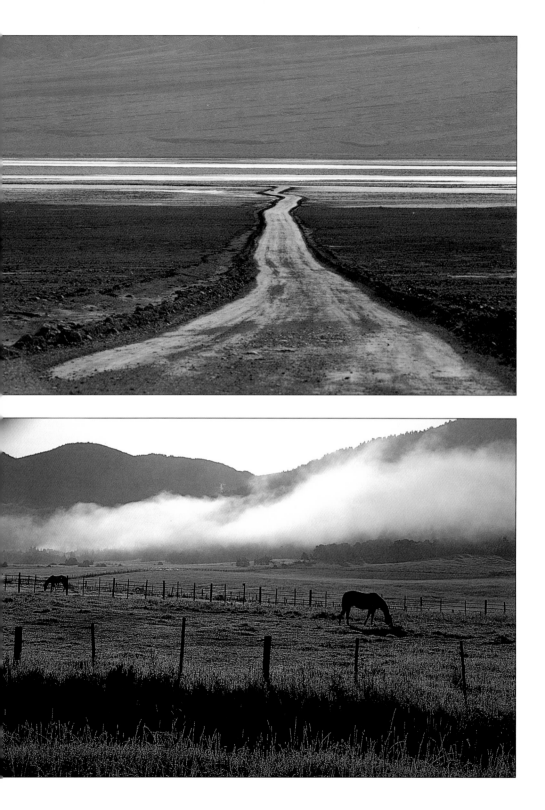

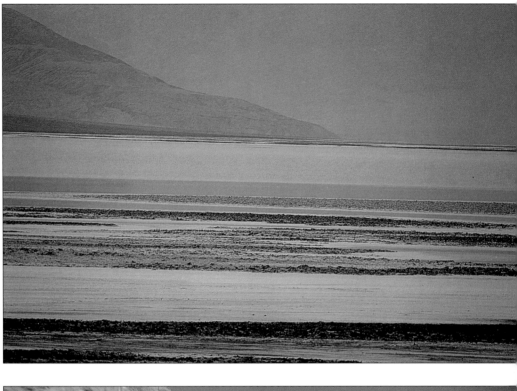

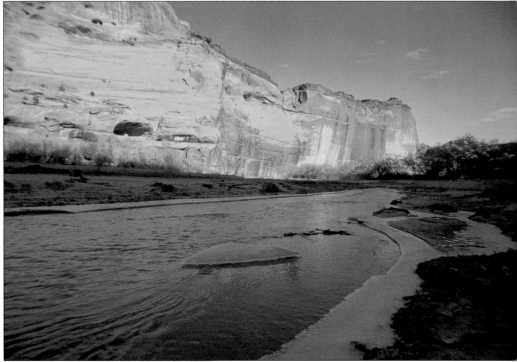

37

your lens, you can see the extent to which it reduces reflections from such surfaces as foliage and water. And by aiming the polarizer skyward, you can see how it whitens clouds and deepens the blue of the sky, thereby making an image dramatic.

Warming filters in the 81 and 85 series help reduce the blue color cast found in forests and high mountains, as well as near water. These filters also enhance the colors of sunrise and sunset. To cut through haze in mountainous locations and elsewhere, use an ultraviolet (UV) filter. To achieve a mysterious or romantic look, try a fog or a soft-diffusion filter, both of which work best in diffused backlighting conditions.

A plain gray neutral-density (ND) filter permits you to use a slower shutter speed when you shoot. This filter is especially handy when you want to create a milky effect for moving water on a very bright day. A graduated ND filter, which is part clear and part gray, helps balance bright and shaded areas in a scene. To do this, you simply have to position the dark side of the filter over the bright area in the landscape.

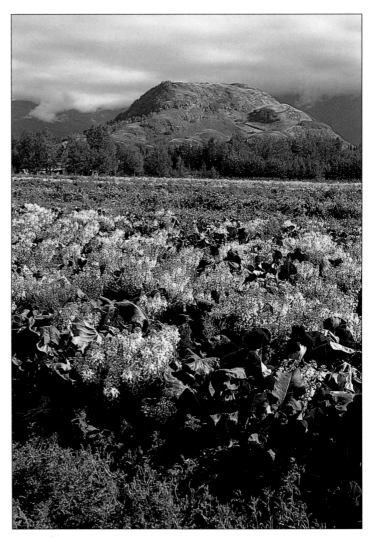

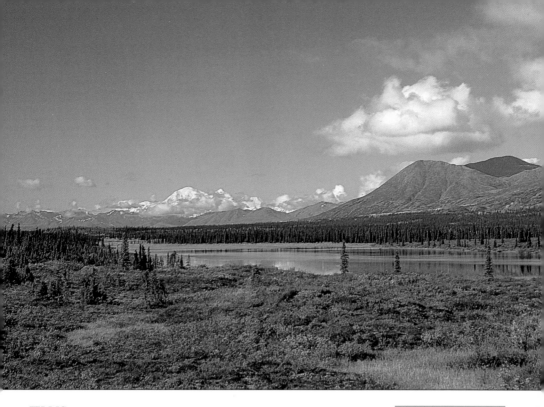

FILMS

Just 50 years ago, photographers were basically limited to black-and-white film. Today, obviously, numerous choices abound. A veritable revolution in films has taken place in recent years, with dozens of new ones having been released in the last few years alone. But with added choices come tougher decisions. And serious landscape photographers must become knowledgeable students of films and how they handle such fundamentals as color, contrast, and reproduction.

Professional photographers, who work with several cameras on each shoot, use different films to photograph the same scene. They then compare the results and choose the one they prefer. The following suggestions should help you make up your mind about the kind of film to shoot.

Such masters as Ansel Adams and Edward Weston made outstanding examples of landscape photography with black-and-white film. Some photographers continue to swear by it as the medium for fine prints because of the strong graphic sense black-and-white film conveys, as well as its full range of tonalities. If you want to work with black-and-white films, Kodak Tri-X Pan, Plus-X Pan, and T-Max 100 are the films of choice. Professionals tend to prefer T-Max 100 to the others for its fine grain, excellent contrast, and ability to retain detail in shadow areas.

Some landscape photographers who work with large-format cameras favor color-print films. They offer some distinct advantages to those who prefer to see their work in prints. These films also have more latitude than slide films, allowing you to correct for exposure errors during developing and printing. In addition, some photographers prefer the subdued colors that print film produces.

If you want to shoot landscapes with color-print film, try one of the Kodak Gold films with film-speed ratings of ISO 100, 200, or 400 and Fujicolor Reala or HG 200. The higher the film-speed number, the faster

Here, I used a UV filter to cut through the haze in the air. As a result, the mountains in the distance became visible from this road approaching Alaska's Denali National Park. A polarizer further enhanced the image by removing reflections and increasing the amount of contrast between the clouds and the sky. I made this shot with my Olympus IS-3 at its 28mm wide-angle setting. The exposure was 1/60 sec. at f/5.6 on Ektachrome Lumière 100.

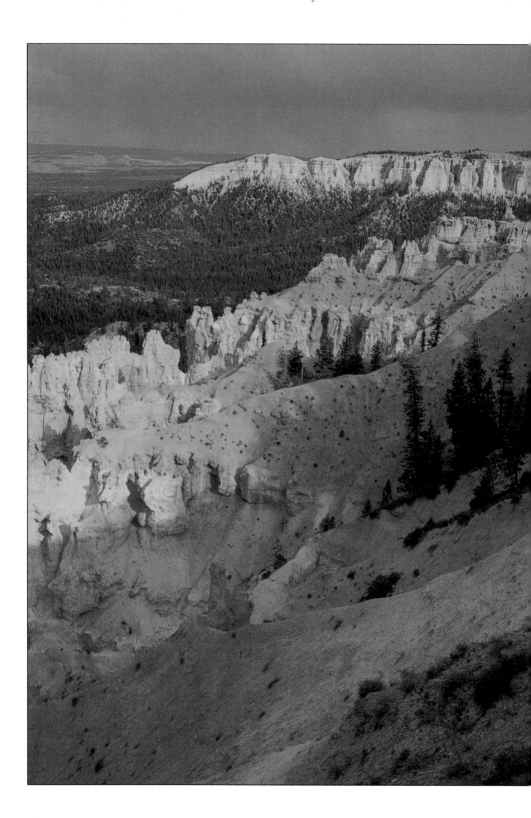

the film. All of these are fine-grain films that produce pleasing colors. Experiment to see which ones appeal most to you.

Color-transparency, or color-slide, film is the preferred film for those photographers who need or like to project their images or who expect to see their pictures published in books or magazines. All of the images in this book were shot with color-slide film, and the instructions are primarily geared to shooting transparencies.

Color-slide films also have the finest grain and resolution of all the types of film available on the market. They render colors very vibrantly, a look that many people prefer; others do, however, argue that the resulting colors appear unreal or unnatural. When you decide which films to choose, keep in mind that transparencies are also considerably cheaper to shoot and to transfer to published media. In addition, if you wish to make a print to frame and display, you can still do so from a slide. Keep in mind, though, that making prints from slides is more expensive than making prints from negatives. As a result, you might want to select only a few of the best to print in order to display them or to send them to others.

As you make your selections from among the many excellent transparency films on the market, your main consideration for landscape photographs should be color rendition. This can differ considerably between one brand and another. For example, Fujichrome Velvia, Fujichrome 100, and Ektachrome Lumière are known for how rich they make greens shot in low light. A new film, Fujichrome Provia, has recently appeared on the market and is reported to be a faster, or more light-sensitive, version of Fujichrome Velvia. Provia is rated at ISO 100, while Velvia is rated at ISO 50. This means that you can use a one-stop smaller aperture or a one-stop faster shutter speed with Provia than you would with Velvia and get an equivalent exposure.

If you want more subdued greens—some would say more true to life—work with Ektachrome 64 Professional EPX film and Ektachrome 100 EPZ film. Kodachrome 25 and Kodachrome 200 enhance warm reds,

For this shot of Bryce Canyon National Park, I used Fujichrome 100 RD film, which intensified the colors by adding a red tonality. Some photographers enjoy the enhanced colors, while others object that they look unnatural. Shooting with Olympus OM-4T and Zuiko 35–70 mm zoom lens set at 35mm, I exposed for 1/30 sec. at f/11–16.

For this shot of Alaskan icebergs, I chose Ektachrome Lumière 100 in order to capture their delicate blues. This film renders blue shades naturally and accurately, while other films distort them somewhat. For example, Fujichrome shifts blues toward purple, and Kodachrome shifts them toward mauve. Here, I used my Olympus IS-3 at its 150mm telephoto setting; the exposure was 1/30 sec. at f/11.

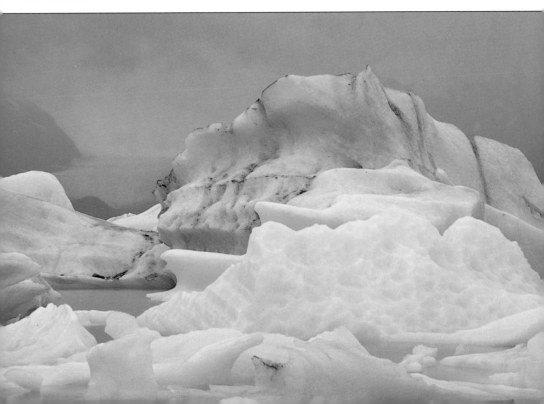

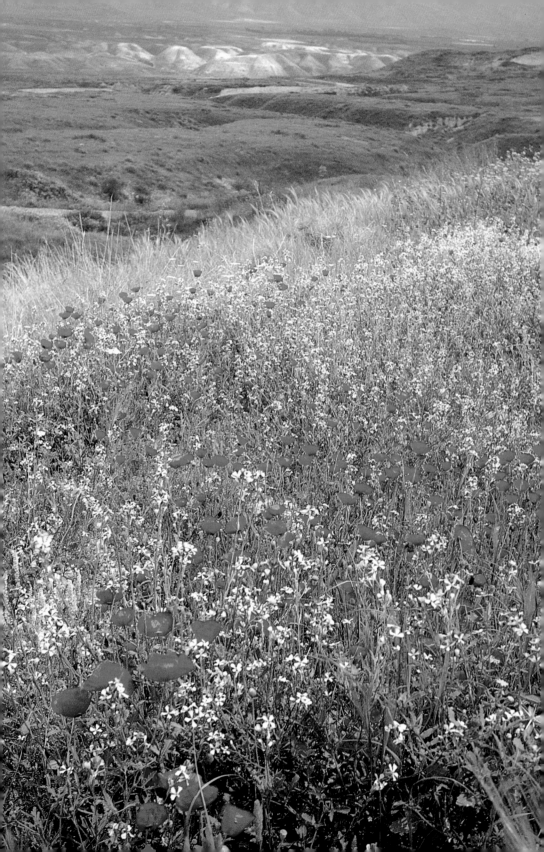

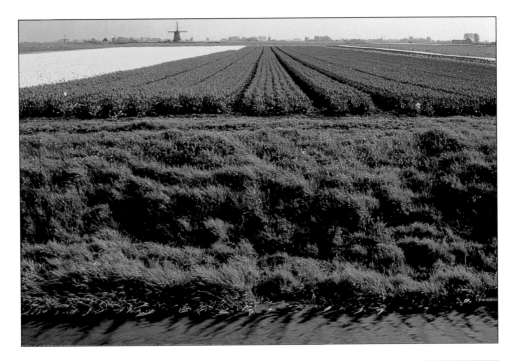

yellows, and browns. To produce gaudier reds, yellows, and blues, you can use any of the Fujichrome and Ektachrome films. And for rendering pastel colors well in uniform, diffused light, use Kodachrome 25, Fujichrome 100, Ektachrome Lumière 100, and Ektachrome 64 Professional EPX film.

While film speed shouldn't be your main consideration, especially if you're working with a tripod, it is an important factor if you expect to shoot in low light. Such lighting situations occur before sunrise, after sunset, at night, in deep woods, and under a heavy cloud cover. The faster the film speed, the more flexibility you have in choosing the best combination of aperture and shutter speed.

If, however, you have only a relatively slow color-print film with you, with an ISO rating of 100 or lower, you can "push" the film to a higher speed. Simply double the speed of the film you're shooting, and reset your camera's shutter-speed dial to that number. For example, if you're shooting Fujichrome 100, set the dial at ISO 200. This will cause the film to be exposed at a faster rating. Be sure to remember that when you bring the film in for processing, you must alert the establishment to push the film one full stop to the faster setting.

Besides film type, you also have to think about the amount of film you need to bring with you, especially if buying more film will be difficult or expensive when you're out shooting. Most serious amateurs shoot two to three rolls of film per day. Keep track of your own tendencies, and bring more film rather than less. You can store excess film in your refrigerator or freezer beyond the official expiration date without any noticeable loss in image quality. With your photographic tools in place, you can consider exactly how to transform the raw material of light into captivating landscape images.

To make the colors of this Dutch landscape snappier and more vivid, I turned to Fujichrome Velvia. This film also increased the contrast, thereby darkening the shadows to emphasize the texture in the grasses and separating the graphic lines of the tulip field. Here, I used my Olympus OM-4T and my Zuiko 35–70mm zoom lens, exposing at f/11 for 1/30 sec.

The fine grain and low contrast of Kodachrome 25 served my need to create a sharp image of this wildflower field in Israel's Jordan Valley despite the harsh illumination. This film also brought out the red of the poppies and softened the whites in the scene. Working with my Olympus OM-2S and my Zuiko 24mm wide-angle lens, I exposed for 1/30 sec. at f/16.

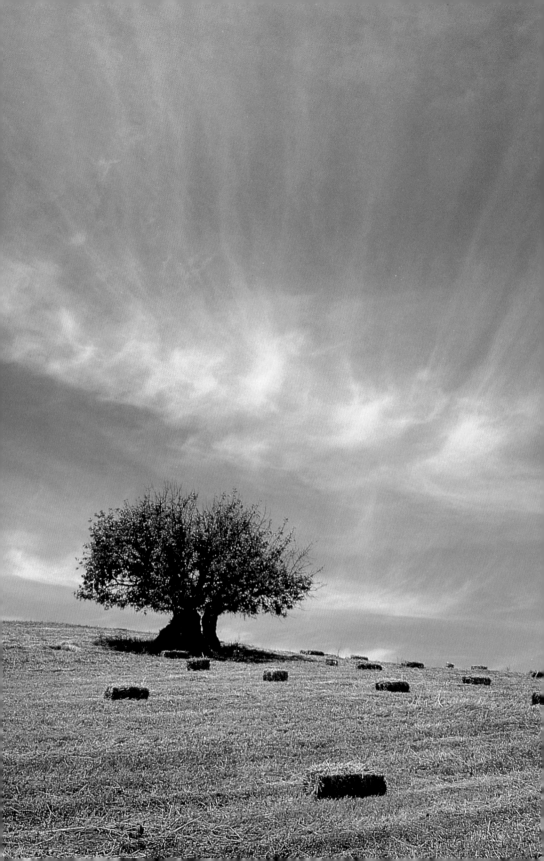

Shooting in Natural Light

Midday illumination has its place in landscape photography. Here, the dark shadows helped define the shapes of the olive tree and haystacks in this Spanish landscape, and the slightly backlit clouds enlivened the sky. I made this shot with my Olympus IS-3 at its 35mm wide-angle setting. The exposure on Fujichrome Velvia was 1/250 sec. at f/11.

Strong, late-day sidelighting brought out the coarse texture and radiant color of this bale of hay. A polarizer, which is most effective when used at 90 degrees to the sun, as angled here, deepened the color of the sky and provided background contrast. Shooting in Colorado with my Olympus OM-4T and my Zuiko 28mm wide-angle lens, I exposed for 1/30 sec. at f/16 on Kodachrome 25.

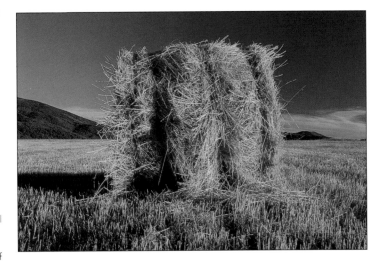

L ight defines the landscape, and the quality of light alters your perception and appreciation of the landscape. Astute photographers develop a heightened sensitivity to light as it changes over the cycle of seasons, during the course of the day, and in different kinds of weather. And dedicated landscape photographers revisit familiar locations just to see how new lighting conditions have altered or transformed them. As you begin to analyze light more fully—and more frequently—you should pay particular attention to changes in intensity, color, and direction.

Autumn comes early to Alaska's Denali National Park. Here, a shaft of light illuminated the russet tundra in the foreground. These fall colors were enriched by their contrast with the distant mountains, which remained in the shadow of overhead thunderclouds. This phenomenon is typical of the season. I made this shot with my Olympus IS-3 at its 50mm standard setting, exposing for 1/60 sec. at f/16 on Ektachrome Lumière 100.

The intensity of light refers to its brightness. Light is strongest when the sky is cloud-free and the sun is overhead. Remember, the sun reaches its highest position and produces the most intense light during the summer. This type of illumination appears white in color and casts dark shadows. You need to carefully handle the resulting high-contrast condition in order to successfully determine exposure.

As the seasons and weather conditions change, as well as at different times of the day, the light becomes less intense and changes color. For example, you should notice and learn how to capture the soft pastel tones of dawn and the fiery reds of dusk. The subtle differences in various intensities and colors of light and the way they transform landscapes are well worth exploring with your camera.

The direction of light depends on the relative positions of the photographer, the sun, and the subject. Most photographers work primarily with frontlighting when they shoot. In these lighting situations, the illumination is directed at the subject from overhead or from behind the photographer. You should try to discover new ways to create evocative images of the landscape. Be sure to experiment with both backlighting, where the light source is behind the subject and is directed toward the photographer, and sidelighting, where the light source is at a 90-degree angle to the photographer and the subject.

SEASONAL CHANGES

During the spring, the light tends to be low and soft and is often filtered through high clouds. Such available light enhances the greens of the new growth. Although these lighting conditions are quite flattering to landscapes, you should also take advantage of the season's rainy and overcast days. The diffused light that characterizes them enriches pastel tones in the landscape. Don't discount foggy days, either; the muted lighting evokes a romantic or mysterious mood.

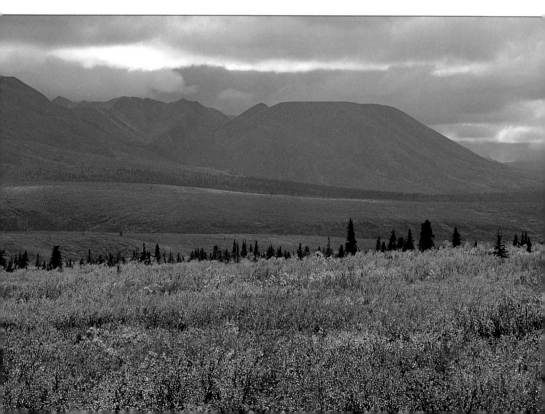

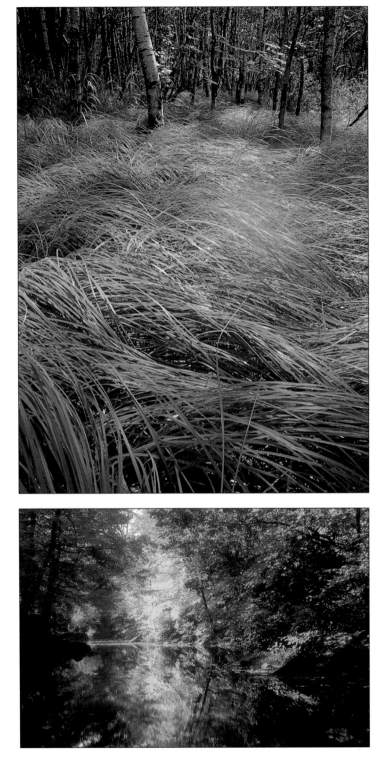

Bright summer sunlight filtered through this grove of birch trees in Maine. The strong directional light cast shadows that accentuated the texture of the long-bladed grass. A polarizer eliminated extraneous glare and reflections. With my Olympus OM-4T and Zuiko 21mm wide-angle lens, I exposed Fujichrome 50 RF film for 1/60 sec. at f/11.

The glow of the late-afternoon autumn light complemented the golden foliage reflected in the Bronx River. Working at The New York Botanical Garden with my Olympus OM-4T and my Zuiko 100mm telephoto lens, I exposed Fujichrome 50 RF film for 1/30 sec. at f/11.

Spring, with its rain and mist, brings muted light to the landscape, thereby reducing contrast and saturating colors. This field in southern France became an abstraction based on color and shape. I made this springtime shot with my Olympus OM-4T and my Zuiko 50–250mm zoom lens. The exposure on Fujichrome 100 RD film was 1/30 sec. at f/11.

The summer brings long stretches of intense light because this is when the sun follows its highest arc. Naturally, this is a boon to those individuals who want more time for picture-taking. But the photographic tradeoffs of this strong illumination are an increase in unpleasant glare and stark extremes of light and shadow.

In order to make the most of summer lighting, you should shoot landscapes early in the morning or late in the afternoon. At these times of day, you can more easily achieve full color saturation and capture the luminous quality of alpenglow, the delicate pink light reflected from the rising sun onto nearby peaks and clouds; sidelighting; or backlighting. Use the long shadows low-angled lighting creates to bring out shapes and textures in the landscape. If you find yourself shooting in the middle of the day, you need to be on the lookout for reflectivity and hotspots on foliage, rocks, and water. Hotspots are the white or near-white spots that very bright light in a dark scene produces. Hotspots often appear manified, particularly when the aperture is set at wide open in order to blur the background. As a result, the hotspots tend to stand out and distract viewers from the rest of the scene. If these problems exist, you can use a polarizing filter to reduce unwanted glare or reflections.

Summer light can also be very changeable, especially in the mountains where sudden storms quite common. Take advantage of the potentially compelling illumination before and after a storm. One way is to include dark thunderclouds as a dramatic backdrop in an otherwise sun-drenched landscape.

Finally, to avoid a washed-out look in your summer landscapes, you'll need to determine accurate exposures in high-contrast lighting. The easiest method is to take a spot-meter reading of the highlights on the land. Another option is to tip your camera down toward the land to eliminate the sky before taking a general meter reading. Then simply lock in that reading and recompose, including the sky if it adds visual interest. If your camera doesn't have a lock-in feature, underexpose from your general meter reading.

As you get more practice shooting at different times of the year, you'll discover that autumn light appears warmer than it actually is because of the golden tones of fall foliage in the landscape. Somewhat surprisingly, colors appear richest at midday. And you can deepen the natural glow of the landscape even further by using a polarizer or a warming filter. And because fall days are, obviously, shorter than summer days, this season's late-afternoon period provides you with warmer light and richer colors to capture on film.

With the sun's rays low throughout the day, winter light is very directional, especially during morning and afternoon. Make the most of this type of illumination by composing to capitalize on the sidelighting or backlighting. But remember, you'll have to work fast to record sunset light because the sun drops quickly in the sky during the winter.

The light of a clear winter day, with its deep, long shadows and bright reflections, can make determining exposure tricky, particularly when the landscape is covered with snow. On sunny days, keep snowy landscapes white by overexposing from the meter reading. On overcast

Winter light often photographs blue because snow reflects the color of the sky. A warming filter can offset the blue. But to add to the eerie mood of this landscape shot of the geyser basin in Yellowstone National Park, I decided to exaggerate the blue by using Fujichrome 100 RD film. With my Olympus OM-4T and my Zuiko 50–250mm zoom lens, I exposed for 1/8 sec. at f/8.

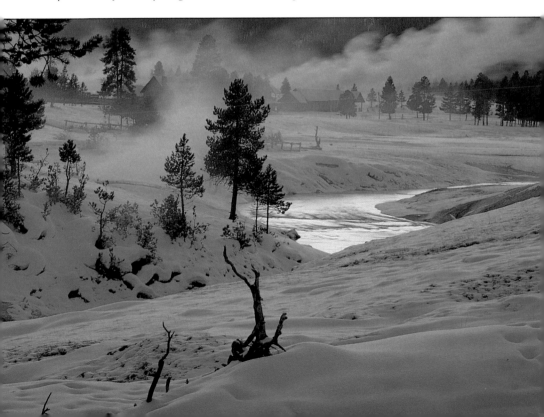

Spring is the season when the desert bursts into full bloom. This short flowering season was well-served by the softly backlit afterglow that followed the sunset in this scene shot in California's Anza Borego Desert. With my Olympus OM-4T and Zuiko 21mm wide-angle lens, I exposed at f/16 for 1/8 sec. on Fujichrome 100 RD film.

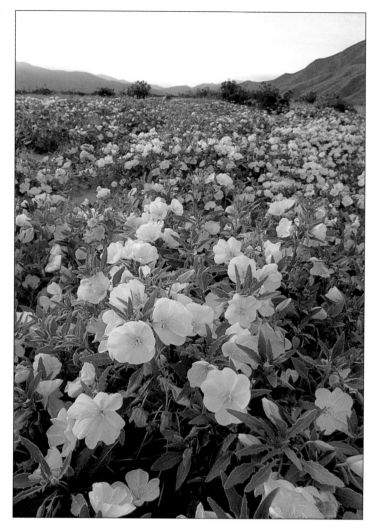

days, however, you should either strive for a monochromatic gray effect or deliberately create eerie landscapes that emphasize the bluish cast of the lighting.

WEATHER VARIATIONS

Changes in the weather have a profound and potentially appealing effect on the quality of light on landscapes. Unfortunately, many photographers make the mistake of limiting their picture-taking to sunny days. This habit gives you a closetful of repetitious images and prevents you from exploring other options that will develop your skills and creativity.

The following suggestions will help you become an all-weather landscape photographer, no matter what the forecast. Of course, you should continue to shoot on sunny days, but you should take a few precautions. In full sun, meter with great care. Always use a lens shade, and avoid facing into the sun when you meter the scene.

In fact, it is best to eliminate the sun and sky completely by tipping your camera down for a general meter reading or by taking a spot-meter

The warm illumination of the low, late-afternoon summer sun caught my eye as I was driving through this Idaho landscape. I underexposed half a stop from a general meter reading in order to saturate colors and to add contrast. As a result, the clouds stood out against the sky. With my Olympus OM-4T and my Zuiko 35mm wide-angle lens, I exposed Fujichrome 100 RD film at f/11 for 1/125 sec.

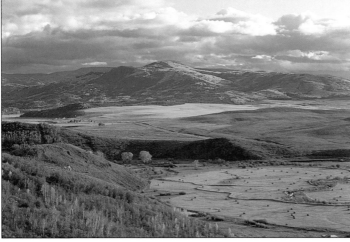

A thick, intermittent cloud cover kept varying the lighting conditions on this broad Colorado mountain valley. I waited until a break in the clouds illuminated the foreground, while the background remained affected by the bright overcast lighting conditions. I underexposed one-half stop from a general meter reading to darken shadows and to enhance highlighted areas. Shooting with my Olympus OM-4T and my Zuiko 28mm wide-angle lens, I exposed for 1/30 sec. at f/8 on Fujichrome 50 RD film.

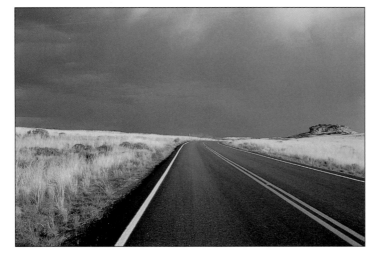

As I drove into Utah's Canyonlands National Park, I faced a dark mass of storm clouds. The brightly illuminated grasses and stripes along the road contrasted magnificently with the looming thunderheads. I metered the clouds and underexposed one f-stop to increase that contrast. My Zuiko 24mm wide-angle lens, which I'd mounted on my Olympus OM-4T, expanded the foreground. The exposure was 1/30 sec. at f/11 on Ektachrome 64 Professional EPX film.

reading of the highlights on the landscape. Lock in that reading, and then compose and bracket by taking one or two shots toward underexpose. If it seems helpful, place a polarizer on your lens in order to reduce glare and deepen the blue of the sky. At high mountain elevations, use an ultraviolet (UV) filter to reduce haze and a warming filter to counteract any blue reflected from the sky. Keep in mind, too, that new films like Ektachrome Lumière and Elite and Fujichrome Velvia and Provia tend to exaggerate blue tones.

As you experiment shooting in all kinds of weather conditions, you'll discover that an overcast sky isn't usually flattering to a landscape. In fact, this type of sky tends to photograph as a blank, colorless space. In most of these situations, you should either reduce the size of the sky in the image or eliminate it completely from your composition by tipping the camera down. Next, meter the middle tones in the landscape—these equal neutral gray in brightness, or the standard 18 percent gray—and use one of the 81 series filters to warm the scene. Alternatively, you can try a graduated neutral-density (ND) filter to deepen the sky.

Clouds can be the starring attractions of your landscape photographs. Billowy clouds enliven a blue sky above a landscape. And if they pass in front of the sun, their edges can filter the light magnificently. Clouds can also strengthen and extend the blazing light of sunset. Incorporating discrete cloud formations can make scenes more dramatic. If the clouds are gray, meter them and then use that reading for your exposure. If they are white, meter the land and underexpose one-half to one full stop. A polarizer can also help keep the clouds whiter and the sky bluer. When you shoot in stormy weather, thick thunderclouds that darken the sky as they roll in juxtapose wonderfully against a landscape still splashed with bright sunlight. Here, you need to meter the landscape and underexpose at one-third-stop intervals up to one full ƒ-stop. After the storm passes, be sure to look for a rainbow, and try to shoot it against the remaining clouds so that it will be more visible. Meter the clouds, not the rainbow, and underexpose at one-half-stop intervals up to one full ƒ-stop. Finally, check to see if your polarizer enhances the image.

During your forays into photographing in various weather conditions, you'll inevitably encounter morning mist and fog, which often cover meadows, coastal regions, and high mountain areas. As the mist moves or rises, it may reveal parts of the landscape, filtering sunlight, softening

Early-morning backlighting on this Colorado mountain meadow brightens the low-lying mist. I spot-metered the gray area above the mist and then shot at that reading in order both to keep the mist white and to silhouette the grazing horses. Working with my Olympus OM-4T and my Zuiko 35–70mm zoom lens, I exposed at ƒ/8 for 1/15 sec. on Fujichrome Velvia.

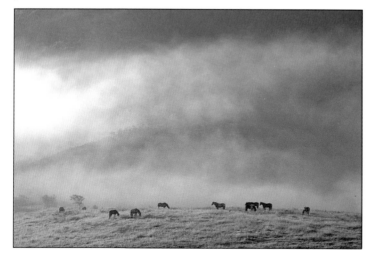

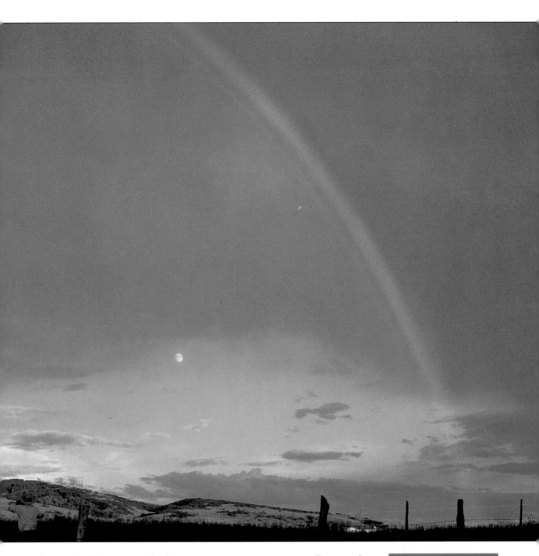

colors, and adding a moody dimension to your composition. Fog, on the other hand, turns a landscape into a monochromatic vista of semi-silhouetted shapes. Meter the mist or fog, and then overexpose by one f-stop to keep it white.

Falling snow also veils the natural colors in a landscape, giving you a chance to create moody, monochromatic images. To counteract the dull light that characterizes this kind of shooting situation, you must be sure to include graphic elements in your composition, such as well-formed silhouettes of trees or lampposts. You also need to overexpose from a general meter reading in order to maintain whiteness.

SUNRISE TO SUNSET

Just as the seasons and weather affect the quality of light, the movements of the sun change as the day progresses from dawn to dusk and beyond. The extremes of the day, sunrise and sunset, offer the most dramatic light for landscape photography. At these times of day, the low-angled

As quickly as this storm gathered, it dissipated, leaving a momentary rainbow in its wake. Speed was essential here. I used a polarizer to concentrate the rainbow's colors and included a sliver of land to provide scale and context. Shooting in Colorado with my Olympus OM-4T and my Zuiko 21mm wide-angle lens, I exposed for 1/60 sec. at f/5.6 on Ektachrome 64 Professional EPX film.

After a hard day of photographing birds in Brigantine, New Jersey, I decided to focus on the landscape. The sun had just set, and the watery marshlands shimmered in the reflected light. The sky was already quite dark, but I knew that I would be able to bring out its red color. To achieve this, I metered the sky and over-exposed by one full stop; this approach also brightened the foreground reflections. I made this shot with my Olympus OM-4T and Zuiko 300mm telephoto lens. The exposure on Kodachrome 64 was 1/8 sec. at f/8.

rays of the sun, which low-lying clouds often filter or reflect, can be breathtaking to look at and inspiring to photograph. This is why avid photographers, amateurs and professionals alike, think nothing of waking before dawn to be at a particular location ready to shoot when the earliest rays of the sun come over the horizon. It is also the reason why they linger at the end of a long day to catch the final glimmers of light.

The light of sunrise and sunset changes quickly, so you must be prepared to work quickly and purposefully; sometimes a hue or shade lasts only a few seconds. Begin by anticipating where the sunrise or sunset will occur. Scout around to find the best perspective for the image you want to shoot. Despite this preparation, it may take you several tries before you get the exact effect you want in the image.

The rising sun casts a pale light that shifts from blue to pink and finally to white. At first light, shadows are long, and the landscape appears flat. As the sun gets higher, shadows darken and shorten, and the contrast of light and shadow sculpts the landscape, rendering boulders, haystacks, and buildings in high relief. On overcast or misty mornings, the ball of the sun may radiate through thin clouds for another interesting effect.

In mountain regions, you may have a chance to see the pink light of early-morning alpenglow. To be ready, you should have everything—your composition, ∫-stop, and shutter speed—set before the sun rises. Bracketing exposures is a must in these situations, and you should do it quickly since alpenglow lasts only a few moments and changes during its brief appearance. Recompose the image only if time permits.

Sunset light is usually richer and warmer than that of sunrise. Furthermore, after the sun sets, the color extravaganza continues for at least 20 to 30 minutes longer. This period is the best time to shoot toward the sun because the land and sky are in better light balance. At sunset, the atmosphere often contains water vapor and dust that both

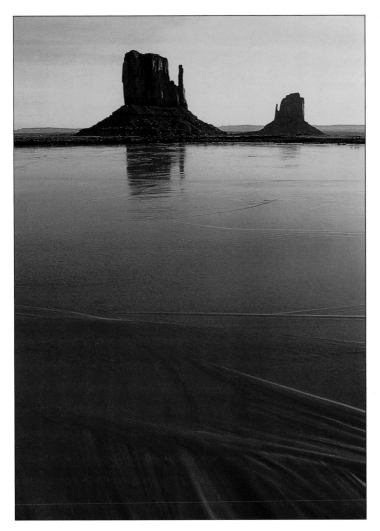

The soft illumination just before sunrise enabled me to maintain the rich colors in the puddle in Arizona's Monument Valley. Underexposing by one f-stop from a meter reading of the puddle deepened the rusty foreground; it also transformed the buttes into dramatic silhouettes against the delicate pink sky. Shooting with my Olympus OM-4T and my Zuiko 18mm wide-angle lens, I exposed for 1/2 sec. at f/16 on Ektachrome 100 EPZ film.

(Overleaf) During a cruise off the coast of southeast Asia, I worked on capturing the afterglow of sunset. Here, the waters of the Pacific Ocean and the wispy clouds above reflected the brilliant colors of the sky. To keep those colors bright, I tipped my Olympus OM-4T and my Zuiko 35–70mm zoom lens upward and exposed for the dark part of the sky above the glow. The exposure on Fujichrome 100 RD film was f/4 for 1/60 sec.

reduce contrast and produce richer sky colors. If you want to enhance the colors of sunrise or sunset even more, experiment with 81 and 85 series warming filters.

The trickiest aspect of shooting at sunrise or sunset is determining proper exposure. The following suggestions should help you do this accurately.

For sidelit compositions—when the sun is at a roughly 90-degree angle to the camera—meter the middle tones on the land, and then underexpose at half-stop intervals. This is particularly important if you want to deepen the colors in the sky or to darken shadows.

If you're shooting toward the sun but you want good exposure on the land, meter the land in this way. In high-contrast backlighting, meter the highlights on the land first, and then overexpose by one-third-stop intervals up to one full f-stop. In low-contrast backlighting—when you're facing the sun, but it is behind clouds—meter the shadow areas on the land, and shoot at this reading. Next, you should bracket at half-stop intervals up to one full f-stop toward underexposure.

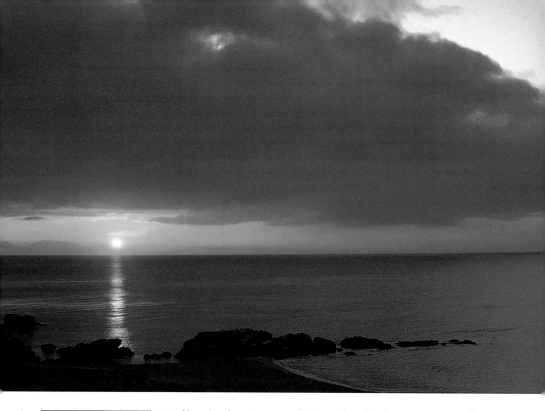

While photographing this sunrise in southern Spain, I was most captivated by the way it affected the colors on the clouds and the Mediterranean Sea. I spot-metered the clouds to make sure that the sun didn't influence the reading; this would have severely under-exposed the shot. But I did underexpose by one *f*-stop from that meter reading in order to deepen the pinks in the scene. With my Olympus IS-3 at its 50mm standard setting, I exposed for 1/8 sec. at f/11 on Fujichrome 100 RD film.

■ If you're shooting toward the sun but the sky is your point of greatest interest, meter the sky to the side of sun first. Your next step is to bracket up and down at one *f*-stop. As a result, the land portion of the image will be underexposed or perhaps even be rendered as a silhouette, but the sky will be more colorful. Remember to use a lens hood when you shoot and to block any flare that remains visible.

■ If the sun is behind you, meter the dominant landscape feature. You should then saturate colors. In order to achieve this effect, you need to underexpose the scene at half-stop intervals to 1¹/₂ *f*-stops.

■ The afterglow in the sky after the sun sets is also worth photograph-ing. When there is no direct illumination on the land, meter the land and then bracket at half-stop intervals toward underexposure. Taking an inci-dent-light meter reading facing away from the setting sun will enable you to accurately determine exposure.

HANDLING HIGH-CONTRAST LIGHT

One of the most difficult challenges landscape photographers face is learning to work well with high-contrast illumination. This is the light commonly found on most bright, sunny days. It is harsh to the eye, casts dark shadows that obscure parts of the scene, and tends to produce extra-neous light—through reflections and glare—that make determining exposure tricky.

One way to overcome these problems is to shoot at times when the light isn't quite so contrasty. Of course, you can't always be at a location when the light is most flattering and easiest to work with. As such, it pays to learn how to make the most of high-contrast illumination by playing to its advantages. You can begin with the following methods.

■ Think of light and dark areas on the landscape as abstract shapes or graphic elements that can play off against one another. For example, set a

Here, I juxtaposed the edge of one dune against another in deep shadow to create this starkly minimalist image. The footsteps added a touch of whimsy. To compensate for the high-contrast lighting at sunset, I metered the bright dune and underexposed by one f-stop. Shooting with my Nikon F2 and my Nikkor 200mm telephoto lens, I exposed for 1/30 sec. at f/8 on Kodachrome 25.

High-contrast sidelighting casts shadows that bring out the varied textures in this Ohio meadow. To saturate the colors and make sure the shadows turn black, I underexposed three-quarters of a stop from a general meter reading of the scene. With my Olympus OM-4T and my Zuiko 24mm wide-angle lens, I exposed Fujichrome 100 RD film for 1/15 sec. at f/22.

brightly illuminated edge of a sand dune against the deep shadow it casts behind it.

■ Use shadows to bring out textures in the landscape.

■ In general, meter the highlights in a high-contrast scene. To expose for the bright areas, shoot at that reading. To achieve greater clarity and detail in the shadow areas, overexpose from the reading.

■ If the contrast range is greater than three *f*-stops, make a conscious decision to expose for either the bright or shadow areas. Most film, and slide film in particular, can't provide good exposure in both. Keep in mind that the bright area will wash out if you expose for the shadow area. Conversely, the shadow area will turn black if you expose for the brighter part of the scene. Basing your exposure on one section of the scene is preferable to compromising between the two extremes and getting a shot with nothing well exposed.

■ Remove unwanted glare or reflections from foliage with a polarizer. Using this type of filter at an angle between 45 and 90 degrees to the sun can also deepen the blue of the sky and whiten clouds.

■ Choose film that will increase or decrease contrast, according to your purpose. Fujichrome Velvia and Kodachrome 200 increase contrast, while Kodachrome 64 and Ektachrome 64 Professional EPX and EPZ films reduce contrast.

■ You can also manipulate contrast during developing and printing. (Consult a darkroom book for complete information about these specialized techniques.)

NIGHT LIGHT

One of the marvels of photography is that film will record an image as long as some light strikes it. This is why wonderful landscape effects are possible even at night. Furthermore, night shots are much easier to achieve than most people realize. For example, you can shoot in the light of the moon and stars using whatever residual light remains from the sun. You can also create stunning night images of an urban landscape by the light of street lamps or office towers. No matter how dim the light source, long exposures allow light to build up for proper exposure. Keep the following pointers in mind when you shoot at night.

■ After mounting your camera on a tripod, use a cable release and a stopwatch so that you can take several long exposures of the same image at varying intervals. Here, you may need to use shutter speeds up to 60 seconds long, and bracketing is a must.

■ Meter the middle tones in the scene, not the highlights. (A spot meter helps pinpoint exposures.) Then manually bracket toward overexposure by first setting your shutter-speed dial to "B," or "Bulb," and then varying your shutter speed—not your *f*-stop—at half-stop intervals up to as much as two *f*-stops.

■ For example, if the meter reading calls for an 8 sec. exposure, bracket by shooting at 4-second increments, such as 12 sec., then 16 sec., and so on. If you can't get a meter reading with your camera set on manual exposure, use the program or automatic modes.

■ Select film that plays up the color effect you prefer; don't base your choice on film speed. For example, films that use E-6 processing tend to turn the night sky very blue, while Kodachrome turns the night sky magenta.

■ Carry a flashlight to enable you to check your camera settings despite the dark.

The sun can get quite bright as it rises in the sky. In this high-contrast situation, I wasn't able to polarize the scene because of the sun's position. As a result, I composed this shot of Colorado wetlands in a way that enabled me to utilize the glare as a band of white in the background, and as sparkling spots of light among the foreground grasses and cattails. Working with my Olympus OM-4T and my Zuiko 35–70mm zoom lens, I exposed Kodachrome 25 for 1/125 sec. at *f*/11.

High-contrast light can help define shapes in the landscape. In this early-morning autumn scene in Colorado, the hill in shadow becomes a black mass against the warmer earth tones of its surroundings, the clear blue sky, and the spotlighted grasses at its base. The reflection intensifies the impact of these strong shapes. I made this shot with my Olympus OM-4T and my Zuiko 35–70mm zoom lens. The exposure was 1/30 sec. at *f*/16 on Fujichrome 100 RD film.

I photographed this city-
scape of lower Manhattan
and the Brooklyn Bridge
just after sunset, when the
sky still had some color
and the city lights were on.
I metered the sky and over-
exposed one f-stop from
that reading in order to
brighten the sky and bring
out the reflections on the
East River. With my
Olympus OM-4T and my
Zuiko 35–70mm lens, I
exposed at f/11 for 4
sec. on Ektachrome 64
Professional EPX film.

On my way to take a sunrise shot of Cathedral Rock near Sedona, Arizona, I noticed the crescent moon hovering over the formation. To make this picture work, I needed to add some color and brightness to the sky, so that it contrasted with the rock formation. To that end, I overexposed two f-stops from a spot-meter reading of the sky. With my Olympus OM-4T and my Zuiko 50–250mm zoom lens, I exposed for 6 sec. at f/5.6 on Fujichrome Velvia.

Developing an Aesthetic Vision

Here, the converging lines created by the furrow lines in this South Dakota field provided the main design element in this image. They also draw the viewer's eye into the distance, thereby suggesting a sense of the third dimension. I made this tight landscape shot with my Nikon F2 and my Nikkor 24mm wide-angle lens. The exposure was 1/30 sec. at f/11 on Kodachrome 25.

The diverse elements of sky, land, and vegetation formed the basis of this tranquil country landscape in Italy. The composition carefully balanced several horizontal bands of unequal size, building the image from the bottom up. With my Olympus OM-4T and my Zuiko 50–250mm zoom lens, I exposed Fujichrome 100 RD film for 1/30 sec. at f/11.

People with an affinity for nature often find that the landscape resonates with a message beyond itself. For nineteenth-century painters of the Hudson River School, the landscape reflected a transcendent presence. Photographers, too, have portrayed the magnificence of the landscape. Early landscape photographers include such giants as Carlton Watkins, Timothy O'Sullivan, and William Henry Jackson. Their documentary portrayals of the West shaped Americans' vision of the frontier and were instrumental in protecting vast areas of natural beauty in the first national parks.

For this landscape in southern France, I portrayed the rows of lavender as an arrangement of converging lines and treated the field, farmhouse, and hazy backdrop as distinct shapes within a picture frame. Shooting with my Olympus OM-4T and my Zuiko 100mm telephoto lens, I exposed for 1/250 sec. at f/11 on Kodachrome 64.

Later photographers, such as Edward Weston and Ansel Adams, captured the drama and majesty of landscape scenes with so much simplicity, clarity, and definition that their images have become icons of American culture and the nation's collective memory. And color-photography masters, including Ernst Haas and Eliot Porter, revealed their individual perspectives of the natural landscape by imposing order on nature's randomness and elevating ordinary scenes to new levels of subtlety and beauty.

In all of these cases, the success of an image depends on the photographer's ability to express an individualistic aesthetic vision. In order to develop such a vision when you photograph landscapes, you need to give some careful thought to several considerations.

EFFECTIVE COMPOSITION

The term composition refers to the arrangement of elements within the frame. When you compose a photograph based on nature, however, you don't physically arrange the elements the way you might in a still life. Instead, you select the position, perspective, and equipment that will yield the arrangement your mind's eye sees. The following suggestions can help you compose successful images of natural landscapes.

One approach is to balance the diverse elements of sky, landforms, and plants in the scene. Before you shoot, think about the relative prominence and placement of each of these landscape elements. For example, if the sky is deep blue and dotted with white clouds, you may want to feature it. But if the sky is dull gray, you may decide to eliminate it completely. The choice is yours, but you should make it purposefully.

Another way to achieve strong compositions is to effectively translate three dimensions into two. Since the film plane is flat, you need to incorporate visual cues that the viewer's eye and mind can translate into a sense of depth. Diagonal or converging lines, such as those formed by paths, roads, or furrows, tend to draw the eye into the distance. And such

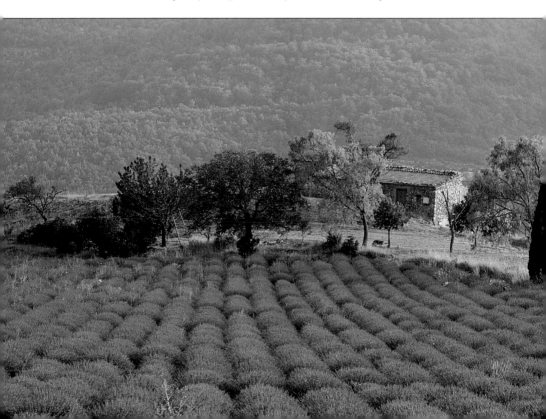

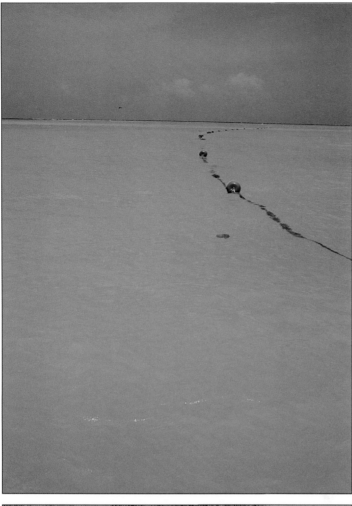

I decided to depict this seascape off the coast of Brazil without a sense of depth. I wanted to show a flat plane that graphically juxtaposed the delicate turquoise water and a stormy sky. The horizontal bands of color produced a simple abstract composition; the line of orange buoys provided the only contrasting touch. I was in the water when I took this shot with my Olympus OM-4T and my Zuiko 24mm wide-angle lens. The exposure was 1/125 sec. at f/16 on Kodachrome 64.

I saw this Colorado marsh as a monochromatic abstract design of lines and shapes. The lines of the individual blades of grass added textural interest, while the clumps formed by the water's flow divided the plane into several triangular shapes. Working with my Olympus OM-4T and my Zuiko 50–250mm zoom lens, I exposed Fujichrome Velvia for 1/15 sec. at f/22.

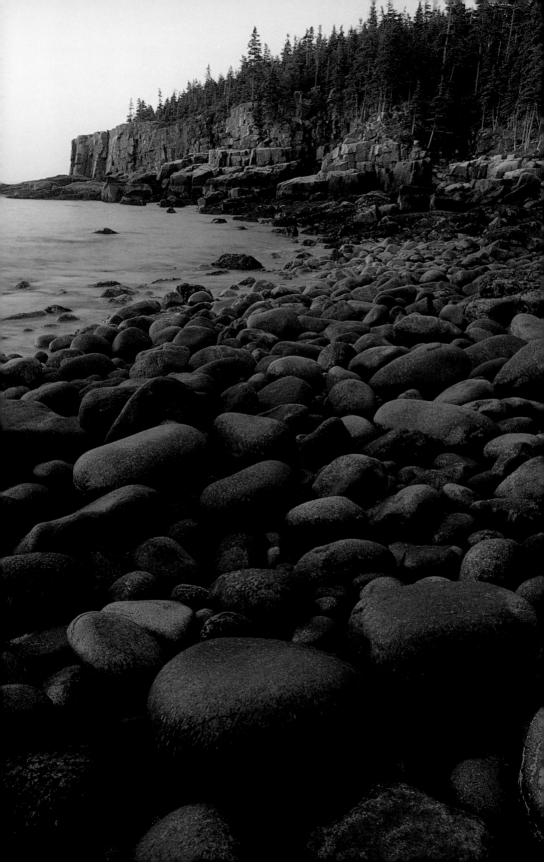

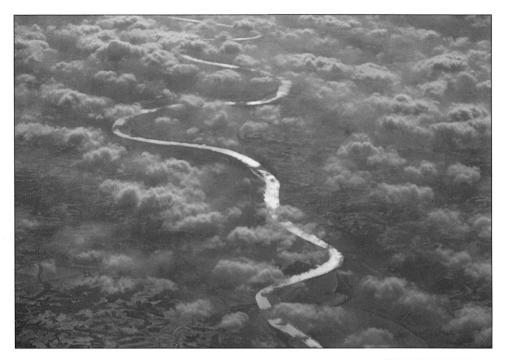

objects as rocks, trees, and flowers that appear larger in the foreground than they do farther away also convey a feeling of depth.

Sometimes, however, you may prefer to forgo creating a sense of the third dimension. To do this, simply juxtapose distant elements as if they were on a flat plane. In these situations, you can use horizontal and vertical lines to compress distances and to minimize the illusion of depth in your composition.

Finally, you need to evaluate each scene as an abstract design of lines and shapes. Learn to look at a landscape not just as a composite of physical objects, such as trees, hills, and flowers, but as an arrangement of abstract lines and shapes within a picture frame. For example, trees then become vertical lines, while a bush or clump of flowers may form a circle. Be sure the arrangement of these visual components strengthens the overall impact of your image.

INCORPORATING COLOR SUCCESSFULLY

It is ironic that despite nature's bountiful palette, many landscape pictures suffer from a repetitious, monotonous dullness of color. This is because photographers tend to shoot at predictable times: during seasons when the landscape is green, on sunny days, and in the middle of the day when the sun is at its brightest. Changing these ingrained habits will enliven your landscape images.

If you make picture-taking a year-round activity, you'll benefit by being able to depict the soft pastels of early spring; the warm, rich colors of autumn; and the muted tones of winter. If you try shooting on overcast and rainy days, you'll be able to record bright, saturated greens and other colors that the sun would have otherwise washed out. If you extend your photographic day, you'll discover that misty dawns provide evocative monochromes, and that late afternoons deepen colors and make them glow.

The meandering line of the Mississippi River created a radiant ribbon of light as seen through the clouds from an airplane. Shooting with my Olympus OM-4 and my Zuiko 50–250mm zoom lens set at 100mm, I exposed for 1/250 sec. at f/5.6 on Kodachrome 64.

For this coastal landscape, I wanted to show the lovely round boulders set against the curve of the Maine shoreline. To make this photograph, I crouched on the rocks and shot from a low perspective with my Olympus OM-4T and Zuiko 28mm wide-angle lens. The exposure on Fujichrome Velvia was 1/4 sec. at f/22.

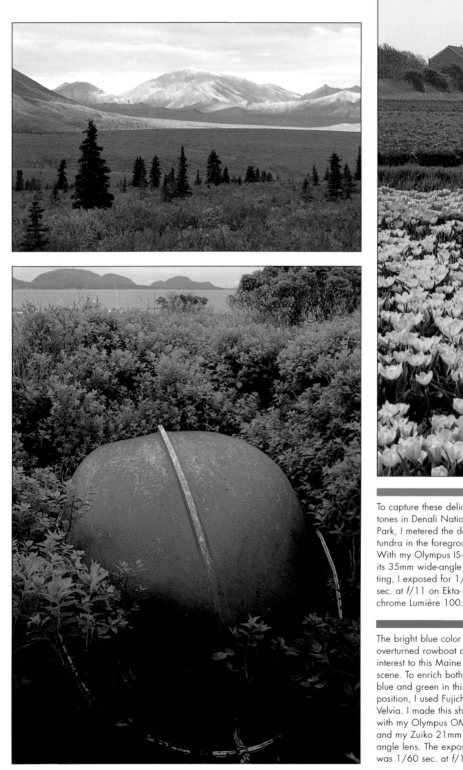

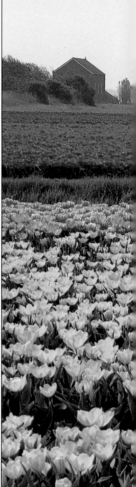

To capture these delicate tones in Denali National Park, I metered the darker tundra in the foreground. With my Olympus IS-3 at its 35mm wide-angle setting, I exposed for 1/60 sec. at f/11 on Ektachrome Lumière 100.

The bright blue color of an overturned rowboat adds interest to this Maine scene. To enrich both the blue and green in this composition, I used Fujichrome Velvia. I made this shot with my Olympus OM-4T and my Zuiko 21mm wide-angle lens. The exposure was 1/60 sec. at f/16.

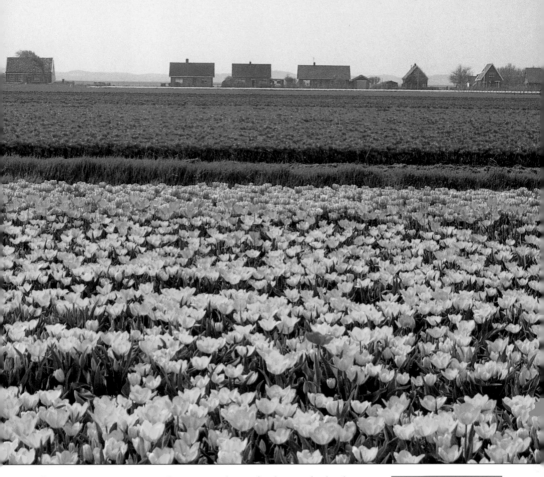

Become more sensitive to the entire palette of colors in the landscape. Think about the emotions various colors evoke, and consider how particular colors can help you make a visual statement. For example, soft pastels evoke a peaceful feeling, vivid reds and oranges convey a fiery excitement, and greens suggest freshness and renewal. Integrate such colorful elements as wildflowers into your overall design, and utilize water and the sky to provide your images with swaths of contrasting color.

Once you are confident about ways to incorporate color into your landscape, you need to work on achieving good color rendition through accurate exposure. Determining the best exposure—not just a good average exposure—means interpreting a meter reading, not following it blindly. You can start with the meter reading, but you should go on to adapt your exposure settings to the kind of light you're working in and the effect you want to create.

For example, you'll find that a monochromatic effect works best in uniform illumination, such as the light early in the morning or on overcast days. To keep pastel shades soft, you may need to overexpose from the meter reading. To saturate bright colors, especially when you're shooting in bright sun, you may want to polarize and underexpose. In high-contrast light, base your exposure on the bright areas and let the shadow areas go black; use them as graphic elements in your composition.

These colorful tulips integrated well with the flat Dutch landscape, giving an otherwise dull setting an exciting focal point. Because I was shooting in intense overcast light, I metered the bright areas—in this case, the yellow tulips in the foreground. Then, to saturate the colors, I underexposed by two-thirds of a stop. I used my Olympus OM-4T and my Zuiko 35–70mm zoom lens, and I exposed Fujichrome 100 RD film for 1/30 sec. at f/16.

Color rendition also varies with the film you use, so choose the one that will work best for the tones in a particular landscape. Cool hues, such as blues and greens, appear noticeably vibrant with Fujichrome films, as well as with the new Kodak films, Lumière and Elite. Some warm tones, including browns, mauves, and yellows, photograph richly with Kodachrome 25, 64, or 200. Golds and oranges, however, record brighter on Fujichrome Velvia and 100 RD film and Ektachrome 64 Professional EPX and EPZ film than they do on Kodachrome.

Some filters also help increase color saturation. A polarizer can reduce glare and reflections, so the landscape's true colors come through undiluted. The 81 series warming filters come in a range of sepia tones—designated A, B, and C from brightest to darkest—that can simulate sunset colors on a dull day. The 82 series blue filters do just the opposite; they eliminate the sun's warm tones. For example, you might try a blue filter if people in your landscape look orange and you want more natural skin tones. Keep in mind, though, that this cooling effect may alter a scene more than you like and potentially overpower it.

The uniform illumination of a rainy day made the greens in this monochromatic landscape of rice paddies brighter and more saturated. I enhanced the cool green even more by shooting Ektachrome Lumière. Working in Bali with my Olympus OM-4T and my Zuiko 50–250mm zoom lens, I exposed for 1/15 sec. at *f*/11.

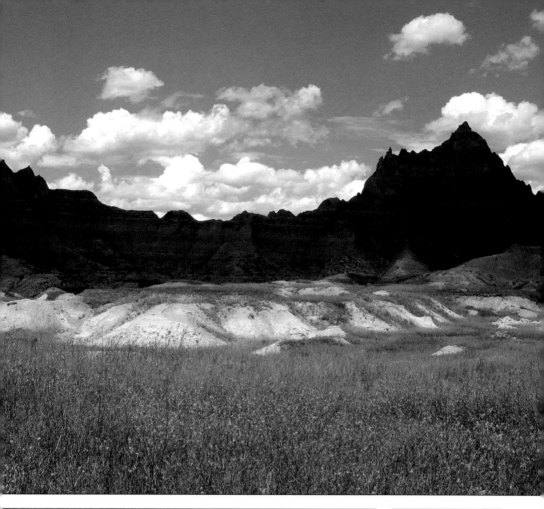

To brighten the tawny tones in this South Dakota landscape, I used Ektachrome 64 Professional EPX film. To enrich the colors further, I put a polarizer on my Zuiko 35mm wide-angle lens. With my Olympus OM-4T, I exposed for 1/30 sec. at f/16.

To get this monochromatic shot, I took advantage of the uniform illumination. I metered the snow and then overexposed half a stop to keep it reasonably white. Shooting in New York with my Olympus OM-4 and my Zuiko 35-70mm zoom lens, I exposed for 1/60 sec. at f/16 on Kodachrome 64.

In terms of good color rendition, another useful filter is the Heliopan warm-tone polarizer. This filter reduces reflections and neutralizes excessive atmospheric blues. As a result, it removes the gray or blue cast that often dulls green tones in the landscape.

GETTING A SHARP IMAGE

Achieving sharpness in landscape photography is a matter of technique far more than it is of vision. This is because, for the most part, landscapes look best at maximum sharpness. You are likely to want part of the scene out of focus only in special situations, such as when you're shooting a closeup of flowers or other details and you want to show them against a mere suggestion of a natural backdrop. The following suggestions will enable you to produce sharp images.

■ Use a tripod and cable release to keep your camera perfectly steady. This is particularly important when you're shooting at slow shutter speeds, such as during or after sunset.

■ Choose the sharpest lenses—those that produce clear, crisp photographs—you can afford. Read the reports published in photography magazines that compare the sharpness of various lenses. But don't go overboard. Most reputable lenses manufactured today are adequately sharp for general-purpose and landscape photography.

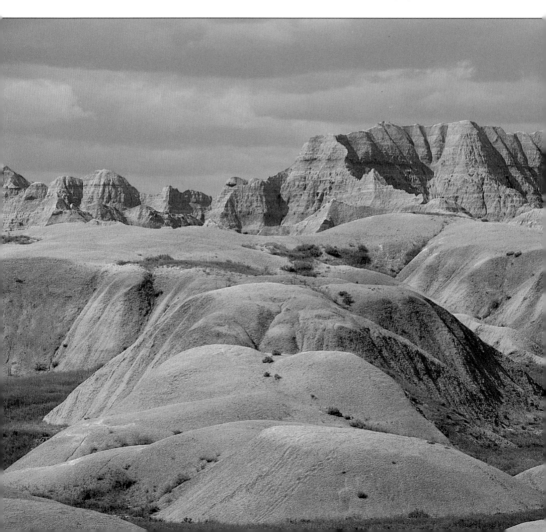

In order to integrate fore-
ground and background
elements in landscape pho-
tographs, give priority to
the optimum aperture for
depth of field. Then by
focusing one-third of the
way into the frame from
the bottom edge, you'll
produce a depth of field
that encompasses the
entire range of the image,
in front of and behind the
focal point. For this coastal
landscape in Maine, I used
my Olympus OM-4T and
set my Zuiko 28mm wide-
angle lens at f/22 to
achieve maximum depth of
field. I exposed for 2 sec.
on Ektachrome 64
Professional EPX film.

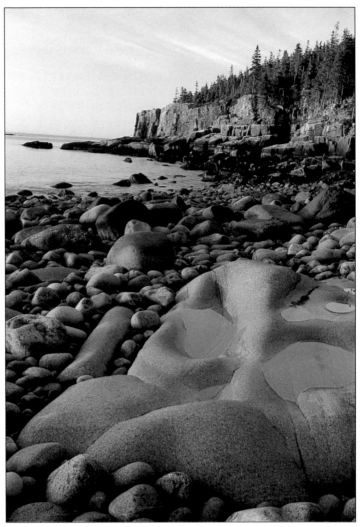

■ Try to shoot at the middle range of your lens' aperture settings, which
is where lenses tend to be sharpest. You'll encounter reduced sharpness at
both extremes. For example, if your lens stops down to f/22, you'll have
slightly sharper images shooting at f/16 or f/11 than at f/22.

■ Set your shutter speed fast enough in order to control the movement
of flowers and grasses in your image. However, there is a tradeoff
between shutter speed and aperture. In general, though, you are better
off giving priority to the ideal aperture for depth of field in landscape
photographs, even if some swaying grasses or flowers register as blurs.

■ To keep textures clear and crisp, take advantage of a polarizer's ability
to reduce unwanted glare. In addition, you should utilize shadows to
increase apparent sharpness. A brightly illuminated foreground set
against a dark backdrop produces a sharp impression because of the dis-
tinct line of demarcation.

As you shoot more and more landscapes, you'll probably come across
occasions when you'll want selective focus. Perhaps somewhat surprisingly,

I gave exposure priority to this flock of woolly sheep, letting the soft greens of the English countryside go light through slight overexposure. This enhanced the image by accentuating the visible mist and by increasing the contrast between the sheep and the backdrop. Setting my Zuiko 180mm telephoto lens at f/4 added to this effect by throwing the background somewhat out of focus. Shooting with my Olympus OM-4T, I exposed Kodachrome 64 for 1/250 sec.

you can still follow the guidelines you used to achieve maximum sharpness in these selective-focus situations. The only change you need to make is to select a shallower depth of field by shooting toward your lens' wider aperture settings.

INTEGRATING WILDLIFE AND THE LANDSCAPE

Animals undoubtedly add a special dimension to landscape photographs, providing an editorial element that shows the relationship of a creature to its environment. Incorporating wildlife also gives images a sense of scale, setting the scene in the visual context of those who dwell in it. This is the reason for the important aesthetic component to decisions you make about including wildlife in your landscape shots.

Most of all, an animal changes the entire feeling of an image because viewers will inevitably notice it before anything else. And like children, animals are great scene stealers. If you have any doubts, notice how many people stop along the road if they see a creature in the wild or even in the relative tameness of a ranch or farm. So your challenge is to maintain a balance between the landscape and the wildlife in terms of color, placement, and dominance.

Think of the color balance as one of contrast. If little contrast between the creature and the location exists, you can expose for the dominant color and then determine whether you want to saturate it further or give it a pale pastel look. Base your decision on your aesthetic sense about the tonalities in your image.

If the animal is noticeably lighter or darker than its surroundings, you'll have to make a difficult aesthetic decision about your exposure priorities. You can opt to maintain the best exposure on the landscape, an approach that works reasonably well if the animal is dark and is rendered as a silhouette. You can also choose to give exposure priority to the wildlife, letting the backdrop go light or dark. This can work if the creature is

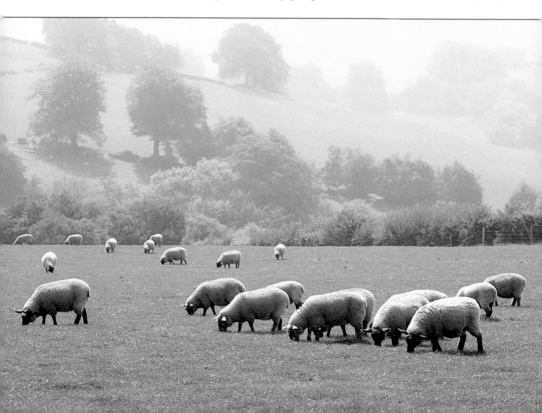

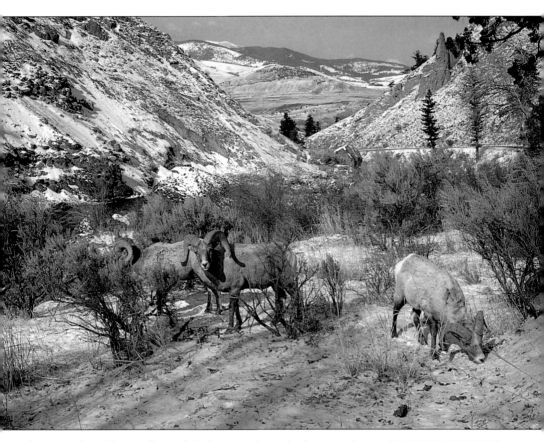

close enough to fill a good part of the frame, such as a bird in a pond or on a branch. A dark backdrop can spotlight the animal, but the landscape will effectively be obliterated by underexposure. Conversely, a light background can appear bland and colorless. Either way, determining exposure will be tricky and the results uncertain, so bracket generously. Finally, you can decide on some compromise setting between the contrasting extremes. Once again, it is essential that you bracket the scene in order to make at least one decent exposure.

If you're focusing on the landscape, you generally won't want the wildlife to dominate the frame. Place the wildlife in a way that complements the natural flow of lines and shapes in your composition, thereby becoming one of a number of elements balanced in the frame. Again, this is a matter of individual vision and aesthetic preference, which requires some thought and deliberate decision-making. This choice may compel you to consider which lens to use. To successfully photograph animals and birds in the distance, use a telephoto lens. It will both magnify the subject and compress space in a way that can be quite pleasing. On the other hand, a wide-angle lens enables you to get close to your subject, when possible, while still portraying the surrounding scenery.

A 35mm lens setting enabled me to get as close as possible to this group of bighorn sheep, thereby permitting me to show them against the wintry scenery of Yellowstone National Park. Working with my Olympus OM-4T and my Zuiko 35–70mm zoom lens, I exposed at f/8 for 1/60 sec. on Fujichrome 100 RD film.

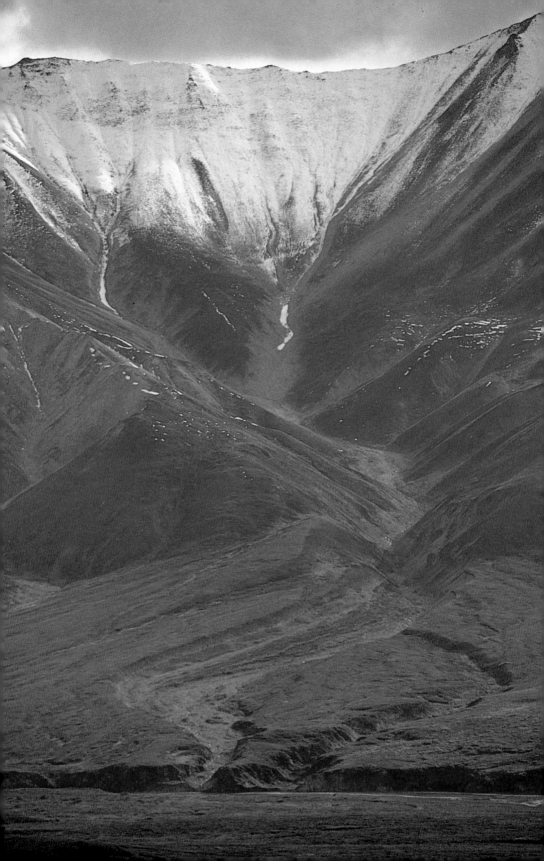

CHAPTER 5

Revealing Landforms

Some landforms reveal the workings of timeless geologic processes. In this image, shot in Alaska's Denali National Park, I wanted to convey the majesty and grandeur of a narrow river valley being formed by the runoff from a vast ice field at the top of a mountain. I used my Zuiko 50–250mm zoom lens set at 250mm on my Olympus OM-4T in order to frame the shot from a distance of a mile. The exposure was 1/125 sec. at f/8 on Ektachrome Lumière 100.

I arrived at this particular spot in Grand Tetons National Park before dawn in the hope of seeing and capturing the delicate, short-lived pink light called alpenglow. Rather than focus on only the sky and the Tetons, I wanted to include the grand panorama of the foreground valley with its carpet of sage. I metered the gray sky and underexposed by one-half stop to concentrate the pink color. I also wanted to maximize sharpness throughout the scene, so I chose an aperture of f/16. Working with my Olympus OM-4T and my Zuiko 35–70mm zoom lens, I exposed for 1/15 sec. at f/16 on Kodachrome 25.

W hat is it that draws people magnetically to experience the natural landscape at all times of the year, and in virtually all types of weather? Those individuals who love nature respond to the land on many different levels. Its vastness offers people a sense of freedom, and its unspoiled terrain suggests what the world was like before the advent of humanity and civilization. Most of all, however, the land conveys a feeling of calm, tranquility, and harmony that eludes many people in their fast-paced everyday lives.

79

Many photographers wonder how they can successfully reflect these qualities in their images. They want to learn, for example, how they can capture Yosemite Valley and its breathtaking beauty. The sheer vastness, geologic history, and spiritual energy call for a grand perspective, a view that enables photographers—and others—to relive their original, first-hand experience each time they look at the picture. Even subtler landscapes, such as the gentle slopes of the English countryside, warrant grand-scale depictions.

But more intimate views of the land can yield other riches. Think of Eliot Porter's crisp vignettes, and study how they reveal the varied textures and muted tonalities of the forest floor. You can also consider the intriguing shapes that nature sculpts, from huge mesas and rock outcroppings to natural bridges and arches. These photograph particularly well in dramatic light, as silhouettes, and at night.

For a closer perspective, you can incorporate the alluring patterns that layers of sedimentation have made. These designs have been twisted and bent by ancient upheavals. You might also want to take advantage of more ephemeral changes in the landscape, such as mudcracks and ripples. You can, of course, go to the other extreme and shoot a distant view from a mountaintop or even an airplane. Discover the graphic designs on the land, and then try to portray them as abstract formations in your photographs.

DEFINING THE GRAND PERSPECTIVE

The power of landscape photographs is most awesome when they successfully reveal a grand perspective. These are the images of landforms that convey the majesty and grandeur—some would say the spiritual dimension—of the natural world. Visually, these compositions show a broad vista viewed from a considerable distance. For example, they can capture the scope of a canyon, the expanse of a valley, or the breadth of

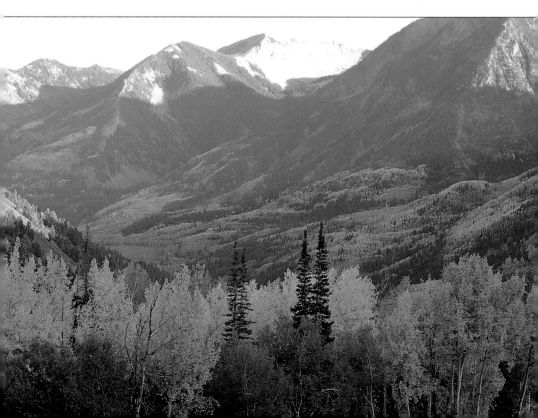

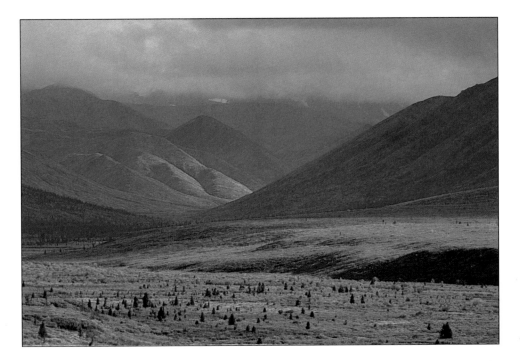

a desert. Rather than reveal to any great extent what lies at your feet, these photographs draw the viewer's eye toward the farthest reaches of the image, as if from the edge of a precipice.

Such pictures require more vision than technique. They depend most on a photographer's ability to compose with clarity and simplicity, and to permit the natural forms of an evocative scene to speak for themselves. This isn't to say that technique is irrelevant. Obviously, a skillful technician can enhance a landscape's visual eloquence. These pointers should help you shoot compelling grand perspectives.

■ To maximize sharpness throughout, always use a tripod. This also enables you to favor relatively high f-stops, even when a slow shutter speed is required.

■ Use a 50mm standard lens to record the sense of grandeur in the scene. If you must have a wider perspective, choose a medium-wide-angle lens, such as a 35mm lens. A lens that is much wider will push the distant land features so far back that you won't be able to retain their integrity and mass.

■ Limit the amount of sky in your pictures unless it adds color or graphic interest. If the sky is unavoidable, meter it separately from the land portion of your composition. If you feel there is too much contrast between the sky and the land, balance them with a split ND filter.

■ Keep in mind that determining exposure can be tricky. In low-angled, low-contrast light, you should meter the middle tones first, then shoot at the meter-reading and bracket toward overexposure at half-stop intervals. In bright daylight, meter the highlights and bracket toward underexposure for good color rendition of every element in the picture except deep shadows.

■ Choose film that best matches your contrast needs. In high-contrast light, select Ektachrome 64 Professional EPX film, Ektachrome 100 EPZ film, or Fujichrome 100 RD film to reduce contrast. In low-contrast light,

For this grand perspective of Denali National Park in Alaska, I wanted to emphasize the soft color palette and the muted illumination. Working with my Olympus IS-3 at its 150mm telephoto setting, I exposed for 1/60 sec. at f/8 on Ektachrome Lumière 100.

(Overleaf) To convey the grandeur of Utah's Canyonlands National Monument, I composed this shot as a continuum of receding landforms enshrouded by wintry mists. I achieved this view by using my Zuiko 28mm wide-angle lens. The lines of this perspective draw the viewer's eye into the frame, and slight overexposure retained the mood of the scene. To maximize sharpness throughout the image, I stopped down my lens to f/16. With my Olympus OM-4T, I exposed Fujichrome 100 RD film for 1/30 sec. at f/16.

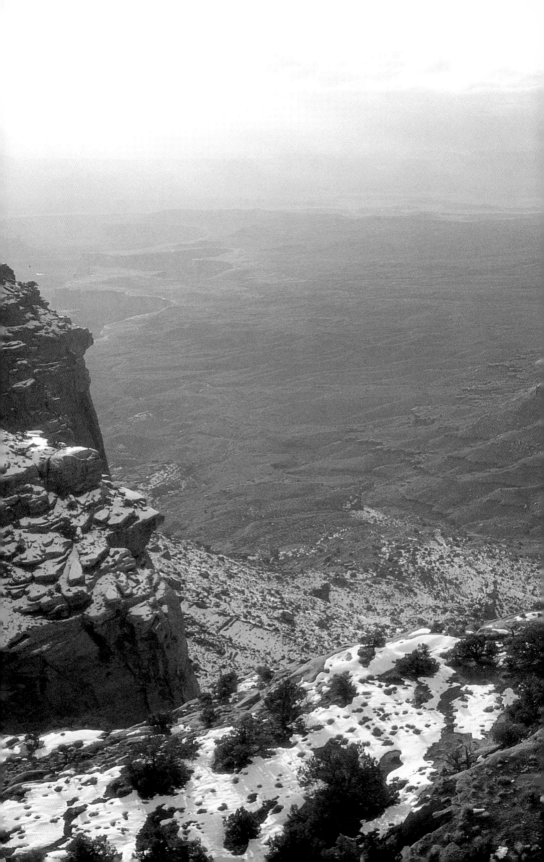

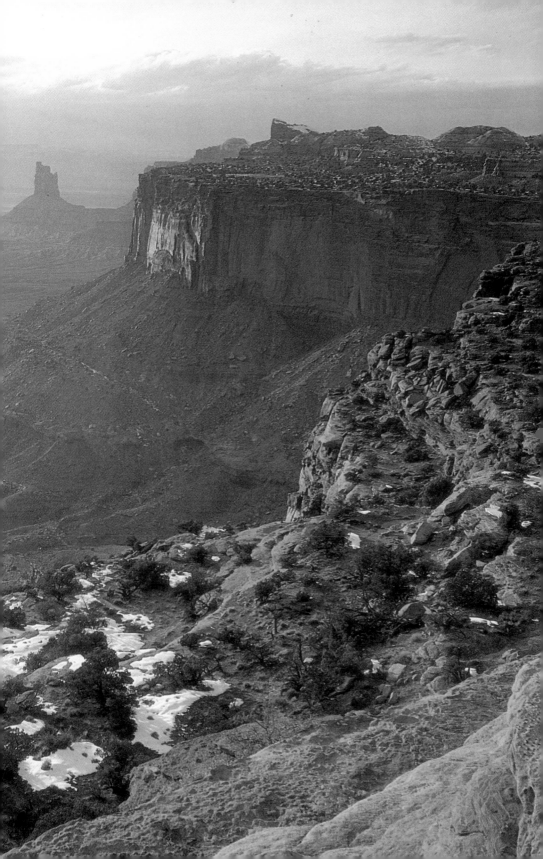

increase the contrast by shooting Fujichrome Velvia or Ektachrome Lumière, and minimize the contrast by shooting Kodachrome 64, Ektachrome 64 Professional EPX film, or Ektachrome 100 EPZ film.

▓ Filters can be useful, too. A polarizer helps you control glare and reflections, while a UV filter cuts haze in mountainous regions. A split ND filter's ability to reduce contrast between a bright sky and a more dimly illuminated land area is most apparent when the horizon line is level. And a warming filter provides a sunset glow even when nature disappoints.

INTIMATE LANDSCAPES

While a grand perspective depicts the vast panorama of a landscape, it often takes a closer, more intimate view to convey the texture of the land. Such intimate landscapes are narrower and more selective and, therefore, demand more of a photographer's personal vision. The photographer's signature is visible through the ability to clarify, define, edit, and frame a meaningful portion within a larger whole. Keep in mind, however, that at its extreme, the resulting image can become so self-defined and detailed—so intimate, in essence—that it loses all sense of a specific location or setting.

Consider an intermediate perspective instead; this type of photograph manages to combine a palpable foreground subject against a visible natural backdrop. In such images, the environment is as important as the featured object, whether this is a cluster of flowers, a well-shaped rock formation, or some other distinctive geologic characteristic. Furthermore, these compositions work best if the foreground item is important in some way, adding color, texture, or mass to the image.

To integrate foreground elements with their more distant surroundings, try the following approaches. First, turn to your wide-angle lenses. These exaggerate the size of the foreground features and at the same time retain much of the background setting. You may want to experiment

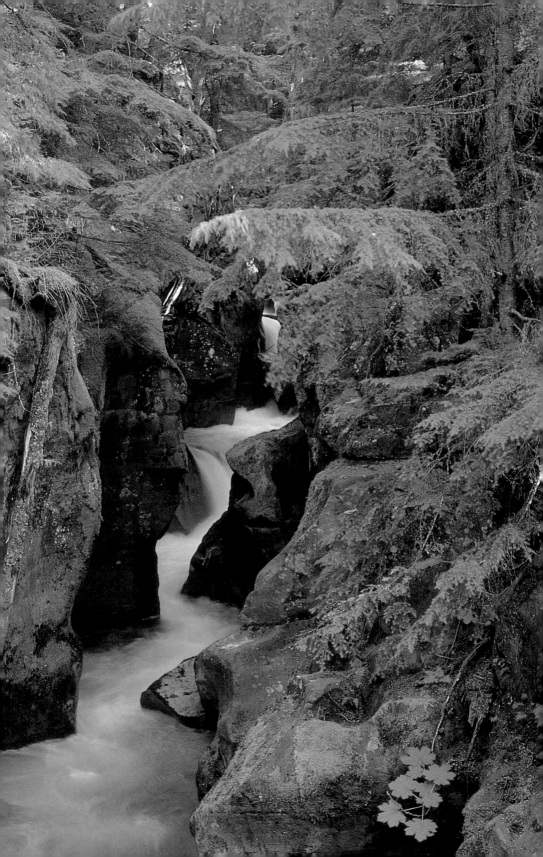

For this Maine landscape, I used my Zuiko 180mm telephoto lens to compress the foreground against the background, and to give the curved line greater definition. I shot with my Olympus OM-4T, exposing for 1/30 sec. at f/8 on Fujichrome 100 RD film.

The contrast of bright yellow and pale gray lichens growing on a dark volcanic rock used color and texture as the basis for an effective detail shot. With my Olympus OM-4T and my Zuiko 90mm telephoto lens, I exposed for 1/30 sec. at f/22 on Fujichrome Velvia.

This geologic detail isolated the swirling lines of minerals in a rock for a dramatic landscape image. Shooting with my Nikon F2 and my Nikkor 50mm lens, I exposed for 1/60 sec. at f/16 on Kodachrome 64.

with lenses up to 21mm, but be careful not to use such extreme focal lengths that the backdrop is pushed too far back, causing its visual impact to get lost.

If, on the other hand, you want to juxtapose foreground and background elements, use telephoto lenses. Lenses in the 80mm to 200mm range compress the space between the two picture areas. Although the result is flat and an unconventional effect for landscape photography, it certainly is an interesting variation.

Whatever strategy you choose for creating intimate shots of the landscape, remember that, as you do with more panoramic pictures, you should avoid metering the sky unless it is integral to the images. And the recommendations regarding exposure settings, film choices, and useful filters apply here as well.

FOCUSING ON EARTHLY DETAILS

While most landscape photographs feature scenery, tight shots that emphasize earthly details can also be compelling. These images usually stand on the strength of their color or their graphic-design elements. Sometimes, though, their success depends on the value of the visual information they convey about their geological subjects.

Because landscape details fill the frame with a limited subject, pictures of them tend to be two-dimensional. Whether you're shooting with a telephoto lens from a fair distance or with a macro lens at close range, the resulting image will be flat with little sense of depth. As such, you'll have to pay special attention to composition; you'll have to work hard to create an image based on the natural lines and shapes that appear within a scene. Look for repeating patterns, sedimentation lines, or graphic textures to enrich your photographs.

Since sharpness is important for detail pictures, you must use a tripod and set the aperture between f/8 and f/16. For maximum clarity, use a

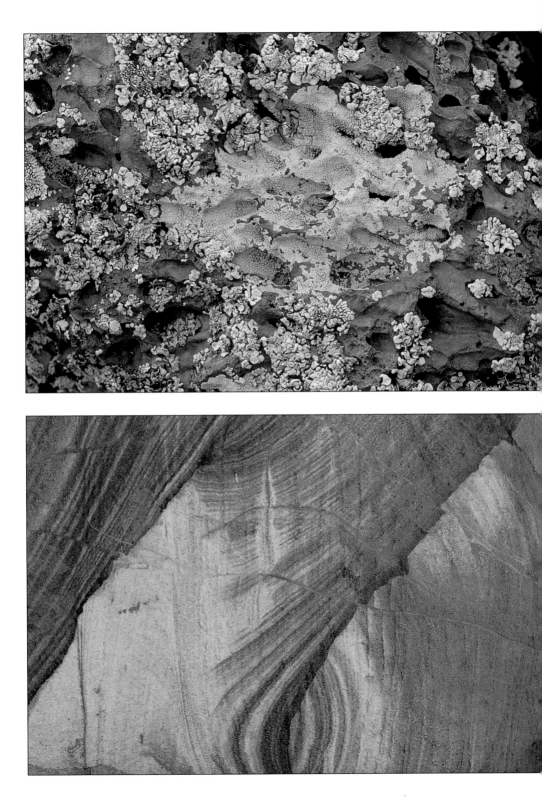

slow film, such as Fujichrome 50, Fujichrome Velvia, Ektachrome Lumière, or Kodachrome 25. The fine grain of these films enhances surface textures.

Determining exposure when shooting details is relatively easy because of the pictures' limited scope. Sometimes, however, the available light might not be uniform or you may decide to saturate the colors in the scene. In these situations, simply meter the highlights and bracket toward underexposure at half-stop intervals.

SHAPING SILHOUETTES

Silhouettes reduce the landscape to pure shapes by utilizing the contrast between light and dark areas. You can create silhouettes at any point during the day, but those you make at the extremes of the day have the advantage of being set against a colorful sunrise or sunset. Because silhouettes depend on their stark, graphic qualities for their impact, you must compose these images with special care. Keep the compositions simple in order to make the landforms stand out.

Experiment with different lenses, including zoom lenses with focal lengths that go from 50mm to 250mm. Each lens or focal distance represents another vision of the same subject. Unless you can previsualize with perfect precision, trying lenses in a range of focal lengths enables you to see the different possibilities. Because the shape of the silhouette needs to dominate the composition, working with various lenses offers you the chance to consider alternatives. Strive to achieve balance rather than symmetry, so that the viewer's eye moves along the frame. Finally, be sure to give the sky value as a shape or form that complements the silhouetted landform in size or color. If you include too much or too little sky in an image, you may throw its balance off.

To enrich the colors of sunrise or sunset, meter the brightest area in the scene, and then shoot at the reading and bracket toward overexposure. This is particularly important if the sun is still visible in the sky. If

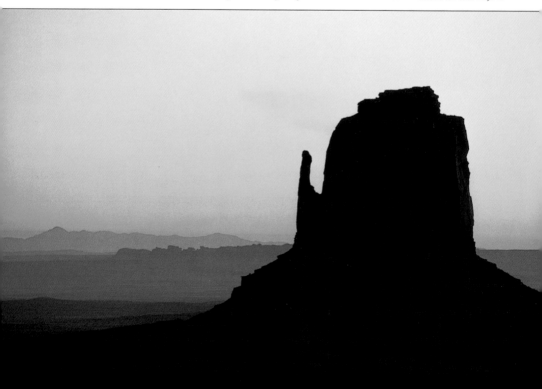

your camera has a silhouette setting, use it to automatically expose for highlights. You should avoid using color-enhancing filters because they'll dilute the impact of the black in the silhouette. Try shooting a high-contrast film, such as Fujichrome Velvia, Ektachrome Lumière, or Kodachrome 64 to sharpen the difference between light and shadow in your silhouette.

AERIAL PERSPECTIVES

Overhead views of the landscape reveal dimensions that you can't appreciate from the ground. For example, from the high perspective of a mountaintop or an airplane, the meanderings of a river become visible and the patchwork of farmlands reveals its charm. If you shoot through an airplane window, you may even discover psychedelic effects that the refraction of light causes.

To get the best results when photographing from an airplane, use the fastest possible shutter speed, at least 1/250 sec. In addition, you should shoot a high-speed film, such as Kodachrome 200, Ektachrome 400, or Fujichrome 400. Fast films counteract the effects of the airplane's vibrations and its movement in space.

Get as close to the window as you can without touching it. Otherwise, vibrations may affect the resulting image. Use your polarizer to increase or decrease reflections and to experiment with the color effects of light passing through the window's mylar coating. As you turn the polarizer, you'll see its effect through your lens.

Since you're shooting from a distance, you should choose a telephoto lens; a lens in the 80mm to 200mm range is ideal. Next, select the largest aperture on the lens. Your camera will then automatically select the fastest shutter speed for proper exposure. An alternative is to take a general meter reading and compensate for the brightness of a wide-open landscape by underexposing half a stop.

The warm tones before sunrise provided the colorful backdrop for this silhouette of the coast of Maine. To keep the colors of the sky rich, I first metered the bright, silvery reflections on the water and then overexposed by half a stop from that reading. Shooting with my Olympus OM-4T and Zuiko 50–250 mm zoom lens, I exposed for 1/4 sec. at f/16 on Fujichrome Velvia.

When you view the Mississippi River from above, its twists and turns are visible. Here, the golden light of the sun's last rays enhanced these natural features, and darkness obscured the rest of the landscape. Working with my Olympus OM-4T and my Zuiko 85mm telephoto lens, I exposed Kodachrome 64 for 1/125 sec. at f/5.6.

This aerial view transformed the light reflected from a reservoir into an intriguing abstraction of psychedelic colors. To achieve this effect through an airplane window, use a polarizer to increase or decrease the reflections of light passing through the window's mylar coating. As you turn the filter, you'll see the effect through the lens. With my Olympus OM-4T and my Zuiko 50–250mm zoom lens, I exposed for 1/250 sec. at f/8 on Fujichrome 100 RD film.

This aerial perspective revealed a meandering river and a road running through a patchwork of farmland. Shooting in North Dakota with my Olympus OM-2S and my Zuiko 35mm wide-angle lens, I exposed for 1/250 sec. at f/8 on Kodachrome 64.

CHAPTER 6

Working with Water

The flow of a small stream, which I captured with a slow shutter speed, conveyed a sense of movement in an otherwise still autumn landscape. Shooting in New Hampshire with my Olympus OM-4T and my Zuiko 100mm telephoto lens, I exposed for 1/4 sec. at f/11 on Fujichrome 50 RF film.

A luminous light reflecting from the surface of the Yampa River revealed its meandering path through this Colorado landscape. I made this shot with my Olympus OM-4T and my Zuiko 100mm telephoto lens. The exposure was 1/30 sec. at f/16 on Ektachrome 64 Professional EPX film.

Travel agents and real-estate brokers know that a lake, a waterfall, or the ocean is the appealing feature that often draws people to particular locations. It is no wonder, then, that the presence of water in photographs has a mesmerizing effect as well. This is true whether people are looking at an image of a serene mountain lake or stream, the gentle cascade of a waterfall, or the pounding surf at the shore. They are captivated by the beauty of the water. Furthermore, images of water can be even more magical than the real thing for two reasons.

First, the camera's variable shutter speed has the power to transform a fleeting movement. A fast shutter speed can capture a decisive moment, such as when a wave crashes on shore, in apparent suspended animation. The same action shot with a slow shutter speed can render the water's movement as a milky, velvety flow. As enchanting as the motion of water is in reality, your camera enables you to make it even more special.

On the other hand, still water can extend the landscape by reflecting anything from an expansive scene to the sky and clouds. A simple, small pond can become a mirror to a vast world. And with an imaginative eye, you'll find a universe revealed in single drop of water.

PERPETUAL MOTION

The camera's ability to accumulate light over a period of time enables photographers to render the movement of water in various ways, all of which are appealing. Suppose, for example, that you want to depict the perpetual motion of a stream, river, or waterfall. You'll need to use a slow

shutter speed, ranging from 1/8 sec. to 2 sec., in order to record on film the water's movement as a milky flow.

Since this effect depends on the accumulation of light, it works best when the landscape scene and the water are in diffused, overcast illumination or in shade. This type of uniform lighting reduces the contrast between the naturally bright water and its surroundings. For the best results, meter the land, and then expose for the most important portion of the landscape. This underexposes the moving water slightly, reducing its whiteness but still leaving it quite bright. Never use a meter reading off the water; it would underexpose the land portion too much. And because you're shooting at slow shutter speeds, you must use a tripod.

A milky effect is much more difficult to achieve in high-contrast illumination. If the difference between the land and water brightness is 3 or more ƒ-stops, you can retain some detail and texture in the water by metering the land and underexposing up to 2 ƒ-stops. You can also decrease the exposure time in other ways: a slow-speed film permits you to use slower shutter speeds, and it tends to reduce contrast; an ND filter slows the exposure time; and a polarizer requires two extra ƒ-stops of exposure time, as well as gives you control over reflections.

If you want to bracket exposures, which is always a good idea in natural light, vary the aperture setting, not the shutter speed. Set the shutter speed to record the water's movement, using a longer exposure time for slower moving water. If, however, you decide to experiment with several shutter speeds to see their effect on the water, you must remember to adjust the aperture setting to maintain a comparable exposure.

Getting the exact effect you like when capturing water in perpetual motion takes practice, but it becomes easier when you gain experience. Try shooting at 1/8 sec. or 1/4 sec. to start. Next, increase the exposure time, and record the settings so you can analyze the results. Many

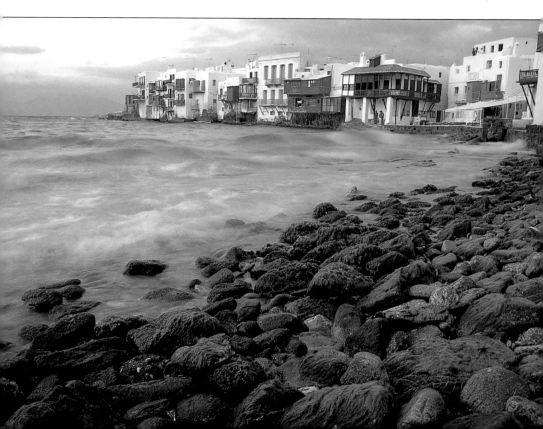

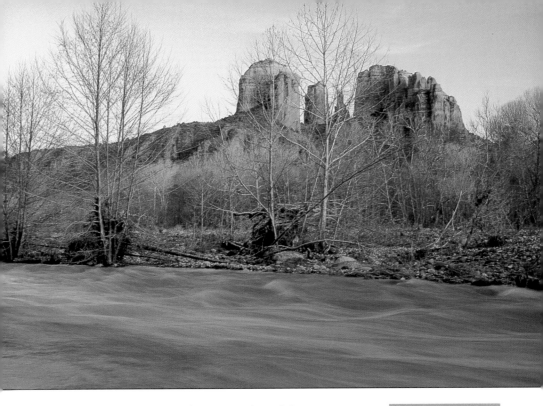

photographers make the mistake of starting with much longer exposures when shooting water in perpetual motion.

THE DECISIVE MOMENT

Sometimes you'll want to freeze an instantaneous moment when you attempt to record the movement of water. At the seashore, for example, you may want to catch the crashing of a wave at a decisive moment. Similarly, if you're shooting in Yellowstone National Park or some other hot-spring basin, you may want to capture the explosive effect of a geyser. On another occasion, you may want to portray the gentle lapping of water along a beach when the demarcation line is distinct.

In all of these situations, your success depends first on your ability to anticipate the movement you wish to record. Remember that you must begin releasing the shutter just before the peak action occurs. Otherwise, you'll be too late, and you'll get less spectacular results. To produce compelling images, you must watch recurring actions for a few minutes to determine the rhythm of repetition. You should also notice variations in those patterns. For example, no two waves are identical, but waves may indicate their force through advance, telltale clues. Become aware of these early warning signs, so that you can be ready to shoot when the right one comes along.

To help you prepare, mount your camera on a tripod, frame the shot you want, and decide on the aperture- and shutter-speed settings ahead of time. You'll then be ready to go into action quickly. You may even want to use a cable release. This will let you watch the scene as it unfolds before your eyes, rather than through the lens.

In general, use the fastest possible shutter speed, especially if the duration of the action is very short. Bracket by using successively faster shutter speeds to see how they render the water's movement. A shutter

To add visual interest to this Arizona landscape, I used a slow shutter speed of 1 sec. I knew that this setting would enliven the movement of this lazy, rolling river. With my Olympus OM-4T and my Zuiko 35–70mm zoom lens, I exposed Fujichrome 100 RD film at f/22.

(Overleaf) I recorded the spray of a crashing wave at Thunder Hole in Maine's Acadia National Park at its fullest by anticipating the moment and using a fast shutter speed. I made this shot with my Olympus OM-4T and my Zuiko 35mm wide-angle lens. The exposure was 1/500 sec. at f/8 on Fujichrome 100 RD film.

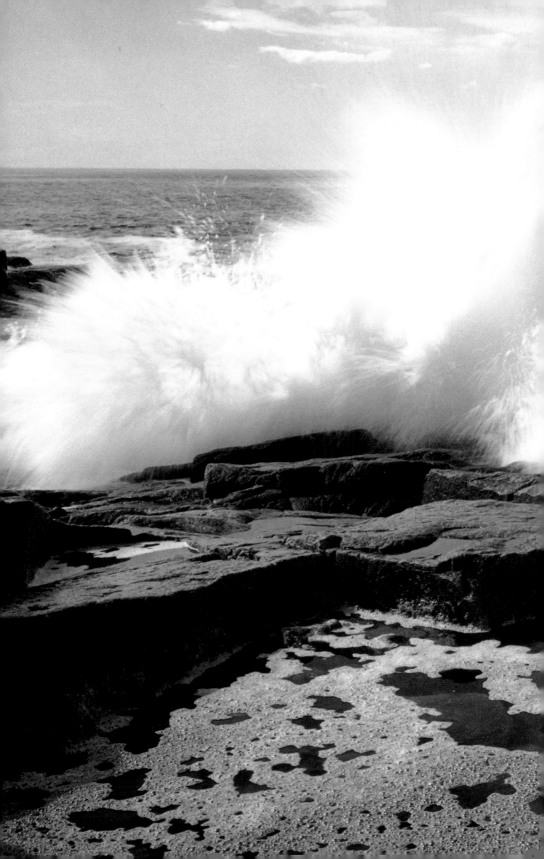

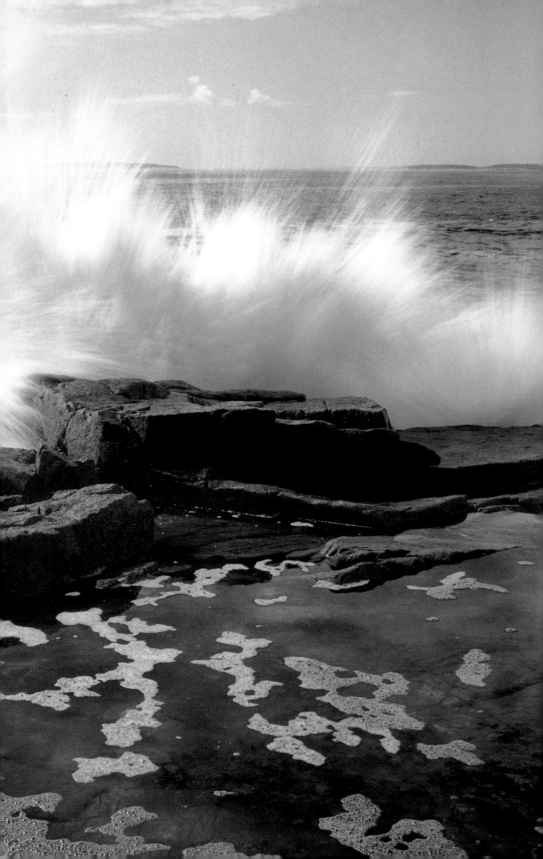

speed of 1/2000 sec. will produce a sharper, clearer image of water spraying from a crashing wave than a slower shutter speed of 1/250 sec. will. You should, however, think carefully about the possibility of using more moderate shutter speeds if the action takes a little longer, as well as if you want to stop some of the movement while letting the remainder record as a flow.

Don't bother using a flash to stop the motion of water when you shoot; landscapes are too large to benefit from the burst of light emitted by an electronic flash unit. The only time a flash can be helpful is when you are very close to a narrow subject, such as a small waterfall. Keep in mind, though, that such moving water often records better as a softened blur with a slow shutter speed.

CAPTURING REFLECTIONS

The mirrorlike surface of still water can reflect aspects of a landscape in ways that add immeasurable appeal to your images. But making the most of such reflections calls for a little know-how. The main challenge is to produce a well-defined image. For the clearest, sharpest reflections, make sure that the water is still. In nature, this may require you to wait a while for breezes to die down. Then use a fast shutter speed of at least 1/125 sec. to counteract small changes on the water's surface. If the water won't hold still, try for a different effect by recording the gentle surface tremors. Be sure to experiment with various shutter speeds since the exact outcomes are unpredictable.

While some blurs can enhance your image, you probably don't want a fuzzy reflection caused by imprecise focusing. Judging from questions that routinely arise in classes and workshops, photographers are somewhat confused about where to focus: on the reflection or on the landscape. In most cases, focusing on the reflection is the better option because it is closer than the scene being reflected. Focusing at the inter-

Few photographers can resist shooting the towering plume of Old Faithful in Yellowstone National Park. Here, dramatic color surrounded and enhanced the geyser's classic shape. I made this early-morning shot in winter with my Olympus OM-4T and my Zuiko 35–70mm zoom lens The exposure was 1/30 sec. at f/8 on Fujichrome 100 RD film.

Deep blue patches of water peering through the algae in this South Carolina swamp intermittently reflected the nearby cypress trees. To keep the reflections as close to black as possible, I metered the water and then underexposed by one full stop. Working with my Olympus OM-4T and my Zuiko 35–70mm zoom lens, I exposed Fujichrome 100 RD film for 1/30 sec. at f/16.

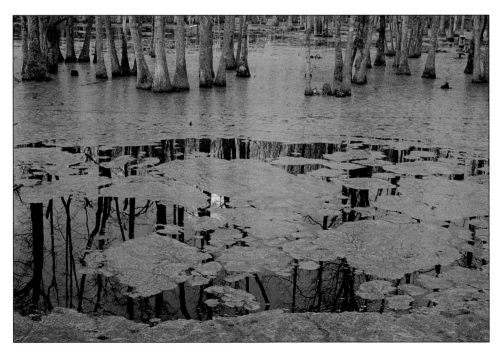

Here, I enhanced the impact of Glacier National Park by shooting a symmetrical scenic reflection of this majestic landscape. Working with my Olympus Stylus camera and my Zuiko 35mm wide-angle lens, I exposed Fujichrome Velvia for 1/30 sec. at f/16.

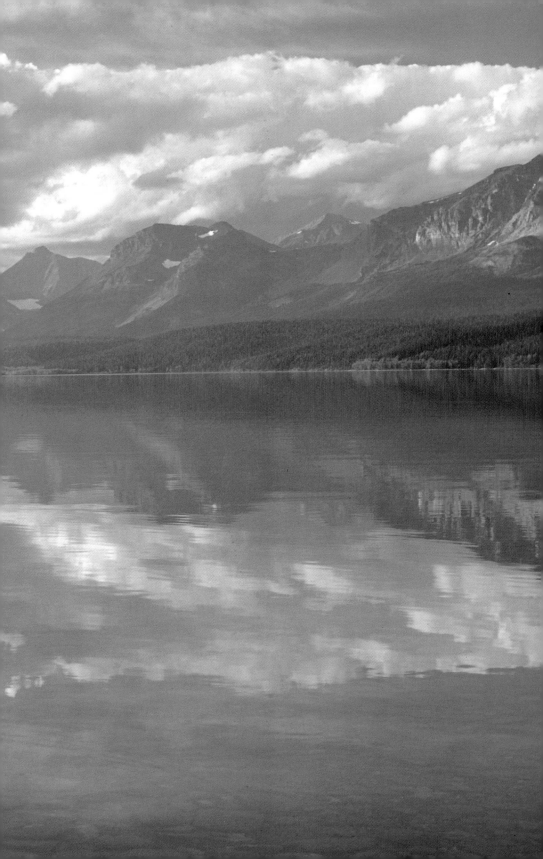

mediate distance of the reflection while using a small aperture provides enough depth of field to keep the surroundings sharp as well.

Next, meter the brightest part of the reflection—but not any glare—and underexpose up to one ƒ-stop to saturate colors. Also, check to see how your polarizer changes the effect of the reflection. Position the filter on the lens, so that it removes only unwanted glare and doesn't affect the essential image.

In terms of composition, reflections invite somewhat symmetrical arrangements. Using a standard or wide-angle lens enables you to combine parts of the landscape and its reflected image. For an interesting change of pace, you can feature the reflection alone. Another alternative is to use a telephoto lens to home in on a portion of the reflection, thereby creating an abstraction.

As this vertical picture illustrates, I often leave space at the top of the frame and even at the bottom for an editor to superimpose a title and text. This Colorado landscape, taken at sunset, served my purpose especially well because of the reflection. I used the natural symmetry of the image to focus near the middle of the frame. A Zuiko 21mm wide-angle lens enhanced the sharpness of the reflection, captured on Fujichrome Velvia for 1/4 second at ƒ/11.

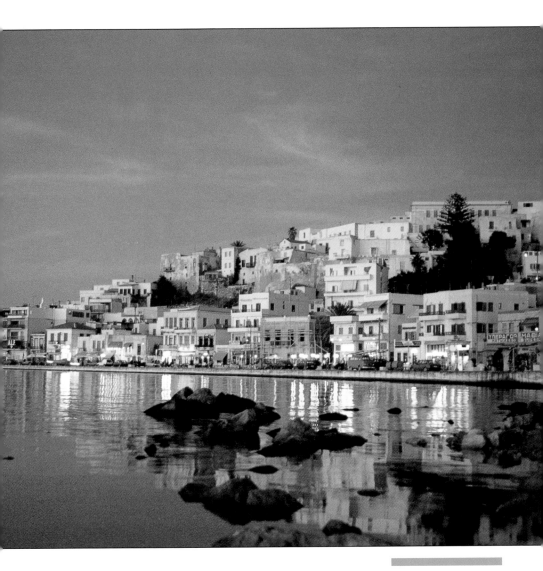

In order to capture the bright lights of the Greek island of Naxos reflected in the bay, I metered the dark water in the foreground and underexposed by a full stop to saturate the colors in the scene. With my Olympus OM-4T and my Zuiko 35–70mm zoom lens, I exposed for 2 sec. at f/16 on Fujichrome 100 RD film.

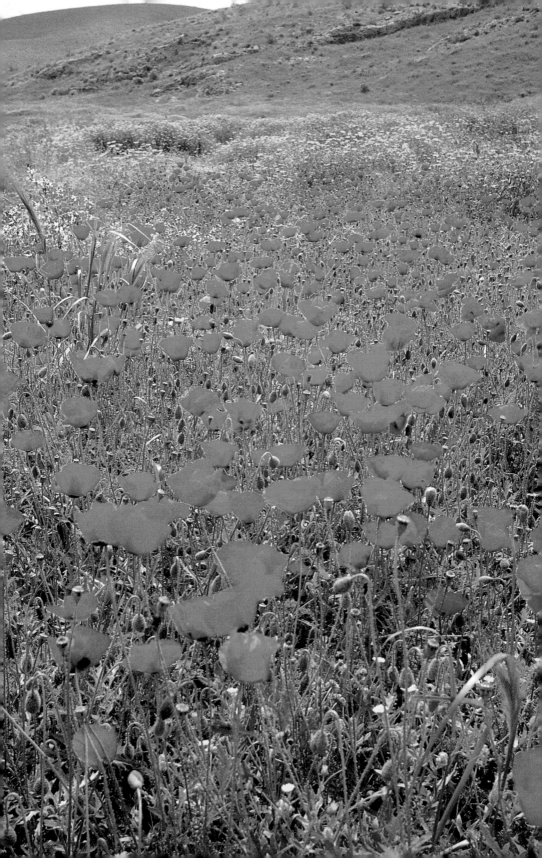

CHAPTER 7

Different Environments

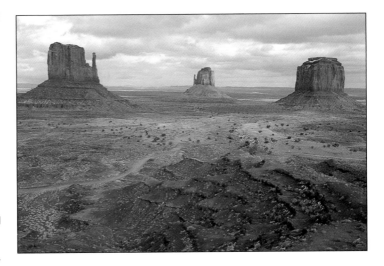

A lush bloom in spring following a wet winter made this desert landscape truly spectacular. To integrate the bright red poppies with the environment and to enlarge them in the foreground, I used a wide-angle lens at close range. Shooting in Israel with my Olympus OM-4T and my Zuiko 24mm wide-angle lens, I exposed for 1/125 sec. at f/11 on Fujichrome 100 RD film.

Wide-open stretches of the desert reveal the shape of the land as few other natural locations can. Here, the distinctive buttes of Monument Valley stood majestically over a haunting desert environment. I made this shot with my Olympus OM-4T and my Zuiko 28mm wide-angle lens. The exposure was f/16 for 1/30 sec. on Fujichrome Velvia.

Mastering the field techniques of nature photography is largely a matter of adapting to the specifics of different locations. As you prepare to take each shot, incorporate what you've learned about light, composition, color, sharpness, perspective, and point of view. This will enable you to reveal the most telling features of the landscape that you want to effectively capture on film. For example, when you shoot in a forest, you need to be able to compensate for the dappled light that is characteristic of this environment.

Wild roses added color and texture to this sweeping coastal landscape in Maine. To keep the mist white, I metered the green vegetation and then bracketed toward overexposure; however, I used the original meter reading for this shot. Working with my Olympus OM-4T and my Zuiko 18mm wide-angle lens, I exposed for 1/8 sec. at f/16 on Fujichrome 100 RD film.

I integrated the rocky Maine shore with the sea and sky by using a wide-angle lens. This lens enabled me to get close enough to the glossy rocks in the foreground to make them prominent while revealing the shape of the coastline in the distance. Shooting with my Olympus OM-4T and my Zuiko 28mm wide-angle lens, I exposed Fujichrome Velvia for 1/4 sec. at f/16.

As you do this, remember that technique is merely the servant of your individual vision. In other words, technique lets you create what your imagination sees as possible. In order to help you achieve your goal, you need to keep in mind some specific technical considerations as they apply to a variety of natural settings.

Each natural landscape will spark your imagination in different ways. Each environment will also present you with particular opportunities and specific challenges. You may find yourself feeling self-conscious or uneasy as you begin to apply the appropriate techniques. Don't be concerned; this is to be expected. Think back to how you felt when you were learning to ride a bicycle or drive a car. With any new skill, the more you practice, the easier and more automatic it becomes. Simply set aside some time each week to photograph a natural setting near your home. Develop your repertoire there, and then expand your techniques on the road as you explore unfamiliar landscapes.

COASTLINES

Coastlines offer landscape photographers the most diverse possibilities in terms of subject matter and light. You can shoot rocky shores, sandy beaches, and seaside cliffs. In addition, coastal vegetation can add color and textural interest to your photographs. Tidal pools invite fascinating closeups and abstractions. And, of course, the changing weather provides both opportunities and challenges.

For general landscapes, find dramatic ways to integrate the elements of land, sea, and sky. Wide-angle lenses permit you to show portions of the land at close range while revealing the shape of the coastline in the distance. If the sky and the water are much brighter than the land, experiment with a split ND filter to counteract the difference in contrast.

Coastal light can range from very bright to dull and misty. In bright light, meter the highlights on the land, and then underexpose the scene

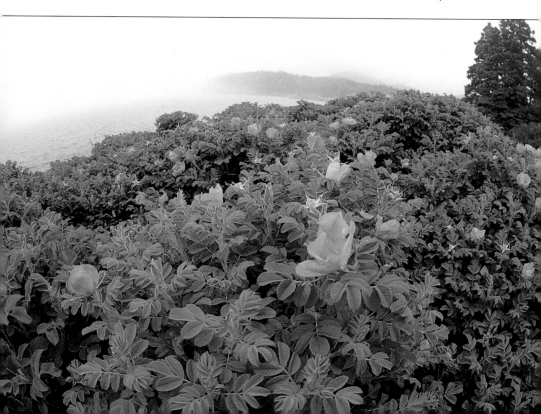

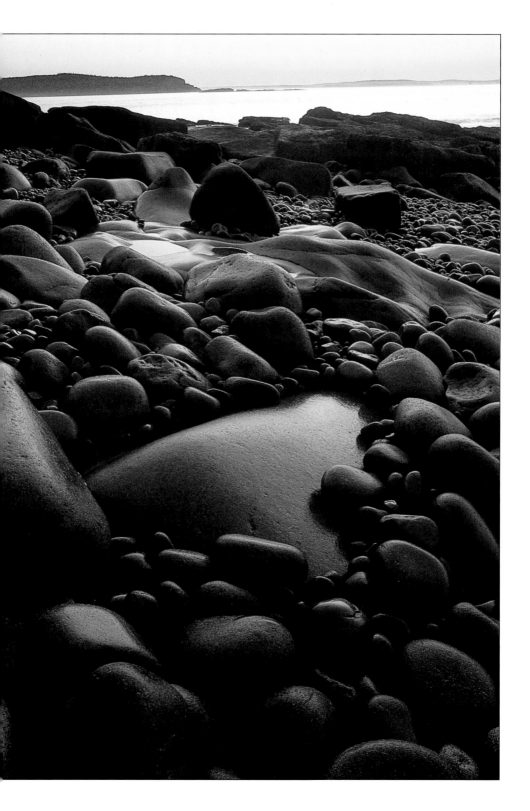

This desert outcropping in Utah revealed eternal geologic processes, such as bedding, stratification, and erosion. I metered the highlights on the land and then underexposed by half a stop to saturate the colors in the full sun and to bring out textures. I then added an 81A warming filter to enhance the earthy tones of the desert. With my Olympus IS-3 at its 170mm telephoto setting, I exposed for 1/125 sec. at f/8 on Fujichrome Velvia.

I made this early-morning shot of a dune field at California's Death Valley National Monument. Working with my Olympus OM-4T and Zuiko 21mm wide-angle lens, I focused one-third of the way into the frame to ensure a sharp image throughout. The exposure was f/22 at 1/15 sec. on Fujichrome 100 RD film.

up to 1½ stops. Use a lens shade on each lens, as well as a polarizer to reduce glare. When you shoot in misty conditions, meter the land, being careful not to meter the mist itself. Depending on how bright the mist is, you should overexpose at half-stop intervals up to one full stop. This will brighten the colors on the land and whiten the mist.

When you shoot in coastal areas, you need to exercise a few precautions. Wear sturdy walking shoes, and watch your footing, especially on slippery rocks. Keep your camera covered until you expect to shoot in order to protect it from saltwater and sand. If spray gets on your camera, clean it with a damp washcloth as soon as you can. When you change films, move into a shaded area that is out of the wind, so that sand won't get into the back of your camera.

It is more important to clean your camera and lenses daily when you photograph in coastal areas than it is in other natural settings. Remove loose particles from the surface of your camera by using a rubber bulb blower. If any particles remain, gently remove them with a camel's-hair brush. Eliminate smudges and dried salt spray by breathing on your filter, lens, eyepiece, or camera, and then wiping it with lens tissue. Never attempt to clean the inside of your camera equipment yourself. Leave this type of cleaning to professionals.

DESERTS

The open landscape of the desert reveals the shape of the land as few other natural locations can. You can see the buttes, mesas, and dunes that give the desert its haunting quality. On a smaller scale, such eternal geologic processes as bedding, stratification, and erosion are apparent in rock outcroppings. Their effects are also visible in windows, arches, and alluvial fans, which are fan-shaped accumulations of particles at the base of an eroded hill or rock formation. These effects are also apparent in such details as mud cracks, salt flats, and dune ripples. You'll find a wealth

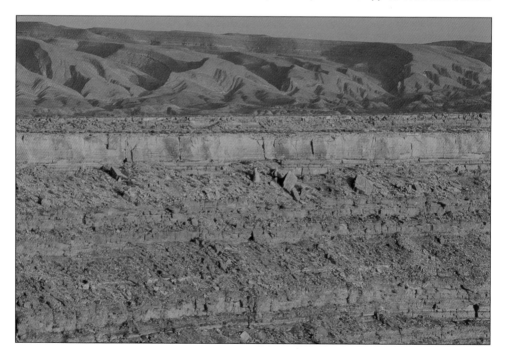

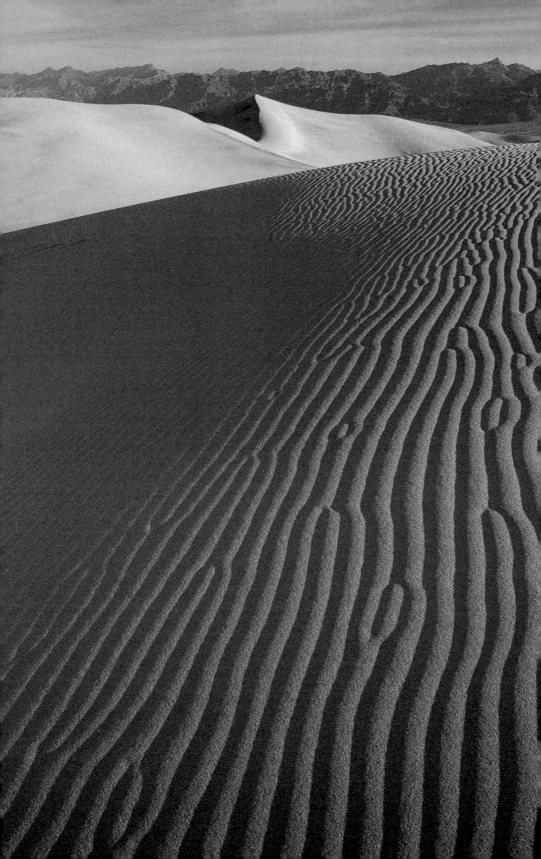

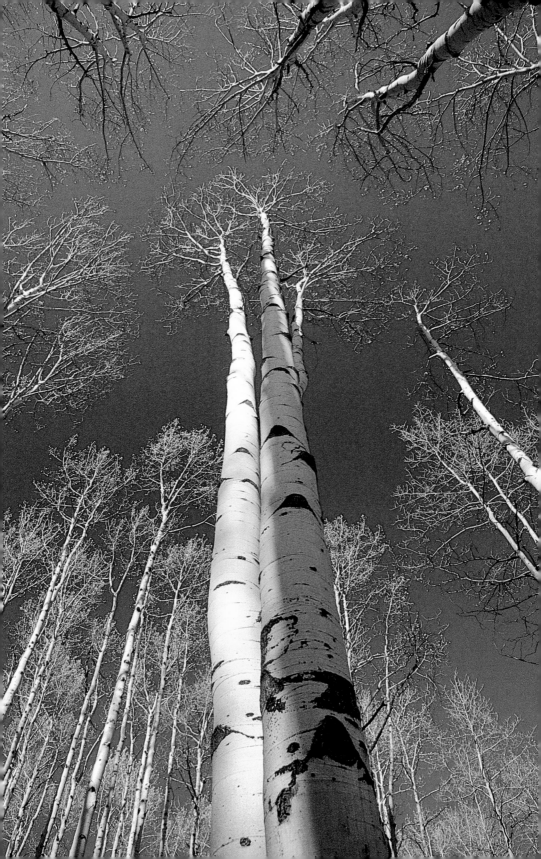

of subjects for images in the desert that can work either as panoramas, vignettes, or detailed closeups.

Distinctive plants and flowers can make the desert landscape truly spectacular. After a wet winter, a lush desert bloom in the spring isn't unusual. This doesn't last long, however, so check with local botanists or area rangers to find out when they expect the bloom and how rich it is likely to be. Integrate the wildflowers into your landscape by shooting either with a wide-angle lens at close range or with a telephoto lens from a high vantage point.

Because desert illumination tends to be quite bright, you should always use a polarizer and a lens shade to control glare. In full sun, meter the highlights on the land first, then underexpose by up to two stops to saturate colors and bring out textures in the scene. For even greater textural relief, be sure to use a slow film with fine grain and shoot early or late. At these times of the day, the low-angled illumination is warm, but temperatures are cool.

The desert is a good place to experiment with filters. Try a warming filter to enhance the earthy tones of the landscape. Another good choice is a warm-tone polarizer, which combines the effects of two filters in one. Finally, to protect your gear from blowing sand, you should keep skylight filters on your lenses at all times. Be sure to clean your equipment daily, too, as you need to when photographing at the coastline.

FORESTS

The forest canopy prevents light from penetrating, so a forest interior is often dark or dim. Patches of light can, however, filter through the canopy. If the illumination is quite bright, the contrast between it and the surroundings is extreme. This makes determining exposure difficult. As long as you can increase the length of the exposure time, your images will turn out fine. In order to accurately determine exposure, meter the middle tones and then shoot at the meter reading with your camera mounted on a tripod.

Dappled light in the forest is another matter. Avoid this uneven illumination if you can because the high contrast it creates isn't especially flattering to your subject. Furthermore, dappled light produces deep shadows and overexposed hot spots. If you must take the shot, meter the shafts of light that beam down. Next, underexpose by up to one stop to saturate the color in the scene.

Another option is to use the bright areas to backlight foliage. If you meter the leaves and overexpose by half a stop, they'll appear translucent. Be aware, though, that the rest of the image may get lost in the background shadows. Bracket toward overexposure if you want to include some shadow detail in the picture; bracket toward underexpose to obscure the background. These backlit vignettes can be quite effective. Alternately, you can train your camera on the uniform illumination of shadow areas, focusing on such intimate landscapes as a view of a brook in the woods; the details of bark, fungi, or wildflowers; or the textures of mosses and foliage.

Another factor that makes shooting forest landscapes so challenging is that it is difficult for photographers to get far enough from their subjects, which are usually tall trees. However, while broad perspectives are hard to achieve, you may be able to shoot a panoramic view from the edge of the woods, a road, or some other opening in the woods. With a little room to maneuver, you may even be able to use a telephoto lens, with a focal length of up to 200mm, to compress a scene, stacking trees against one another.

I used a vertical format and a wide-angle lens to photograph these tall aspen trees in Colorado. Shooting upward, I framed the image carefully, so the tree trunks converged toward the sky in an aesthetic arrangement. Polarizing the scene brought out the white of the tree bark and deepened the blue of the sky for added contrast. Working with my Olympus OM-4T and my Zuiko 28mm wide-angle lens, I exposed for 1/30 sec. at f/16 on Ektachrome 64 Professional EPX film.

(Overleaf) Bright sunlight filtering through a woodland canopy created this vignette. To highlight the translucence of the backlit foliage, I metered the green leaves in the shaded area and then overexposed by half a stop. Shooting along the Bronx River in The New York Botanical Garden with my Olympus OM-4T and Zuiko 100mm telephoto lens, I exposed for 1/30 sec. at f/16 on Kodachrome 64.

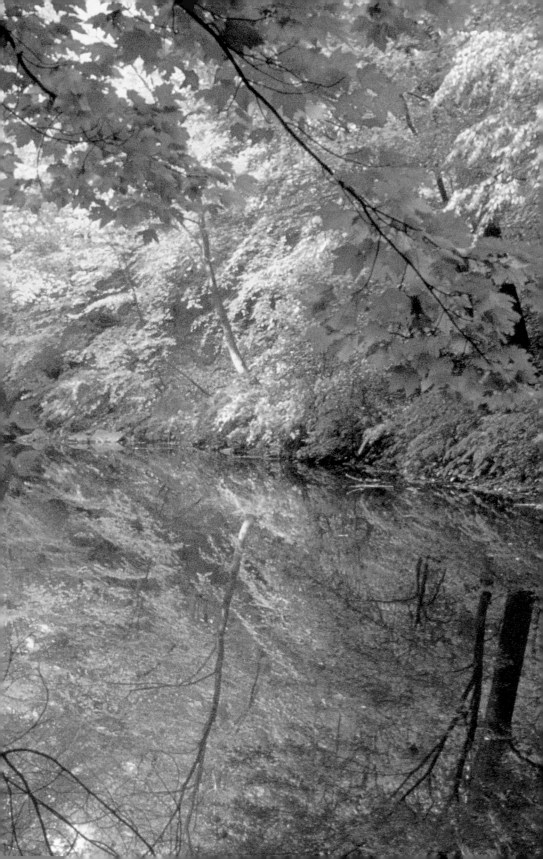

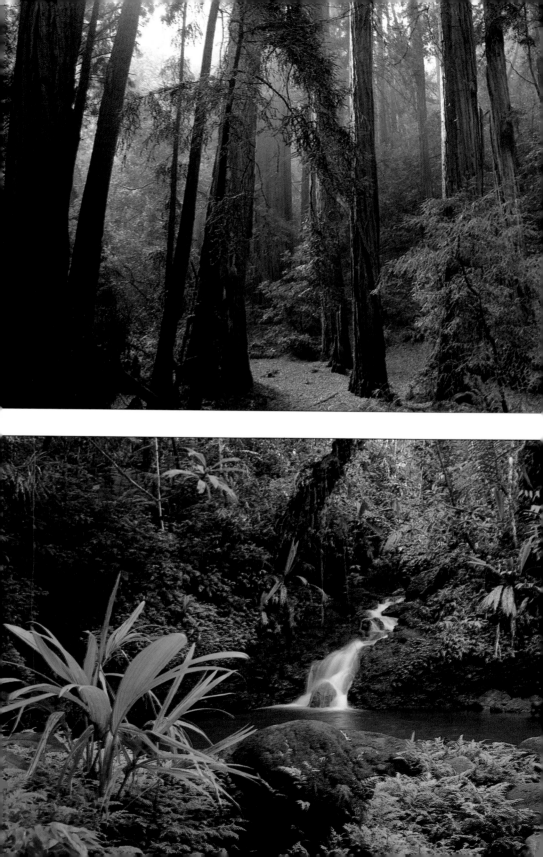

In the forest interior, photographing tall trees usually means shooting upward. Use a vertical format to include more height and at least a 35mm wide-angle lens to broaden the scope. Avoid ultrawide-angle lenses for these pictures because they'll distort the trees too much. Frame the shot carefully, so that the tree trunks converge toward the sky in an aesthetic arrangement. (Be sure to use a polarizer to remove reflections from leaves or to intensify the blue of the sky.) You can also try a perspective-correcting (PC) shift lens, which will minimize the effects of parallax—the apparent difference between what the photographer sees through the viewfinder and what the film actually records—as you shoot upward. The front element of a PC-shift lens can move up, down, or sideways.

More important than suggesting the height of trees is capturing the feel of the forest atmosphere. Revealing the misty light, the textures of mosses and other ground covers, and the mixture of plants that grow near each other strengthens your images. But this can be very difficult because few natural lines or organizing elements exist in a forest. As such, you should take advantage of the parallel lines of tree trunks to help you plan your composition. Then build the image with the rich assortment of woodland textures. To maximize sharpness throughout the picture, focus one-third of the way into the frame, and use a small aperture and, if possible, a 35mm wide-angle lens to achieve maximum depth of field. If the scene has a bluish cast, try an 81A warming filter to neutralize the cool tones in the atmosphere.

The lighting conditions and the colors you want to emphasize will dictate your choice of film. To brighten greens and make them more pungent in diffused illumination, consider shooting Fujichrome Velvia, Fujichrome 100 RD film, and Ektachrome Lumière. To record greens in bright sun, try Ektachrome 64 Professional EPX film, Ektachrome 100 EPZ film, and Kodachrome 25 and 200. The warm colors of fall foliage appear gaudier and more vibrant with Fujichrome and Ektachrome films, and softer and richer with Kodachrome and Agfa films. Naturally, you'll make your selection according to your preference. And remember, a warming filter further enhances fall colors.

MEADOWS

With their wide-open spaces and colorful vegetation, meadows are a delight to the eye. The challenge for the landscape photographer is to make them appear as interesting in images as they are in life. This often requires giving them a visual focal point. For example, a photograph of a meadow succeeds when the landscape is punctuated by a tree, a rock outcrop, a bunch of flowers, a barn, or a fence. Clouds can also become visual magnets. Such elements, thoughtfully placed within the composition, will draw the viewer's eye and allow the meadow to play its role of providing atmosphere or ambiance.

A different approach is to get close to the ground and feature the textures, colors, or patterns of what is growing in the meadow. A 50mm standard lens is suited for tight shots of a portion of the field, especially when you shoot from a slightly elevated perspective. By working with a wide-angle lens—even an 18mm ultrawide-angle lens—you can get down lower and exaggerate the foreground grasses or flowers, and let the rest of the meadow swoop away in the distance. And by using a telephoto lens with a focal length of around 100mm, you can compress and frame the meadow grasses and flowers against a contrasting background, such as a wooded area.

Sharpness is vital to most landscape shots of meadows, particularly those photographs that emphasize texture. To maximize sharpness, you'll

To get a broad perspective in this forest environment in California's Muir Woods, I looked for a clearing that would permit me to get far enough away to show the tall trees. I used the parallel lines of tree trunks to help organize the composition. Working with the dim, uniform illumination of the forest interior was easy. I simply metered the middle tones, the grays and greens, and then made a long exposure. Shooting with my Olympus OM-4T and Zuiko 28mm wide-angle lens mounted on a tripod, I exposed for 1/8 sec. at f/11 on Ektachrome 64 Professional EPX film.

Capturing the forest atmosphere can be difficult when few natural lines or organizing elements are present. For this shot of New Guinea's Hunstein Forest, I built my image around the rich assortment of woodland textures. I used a slow shutter speed to turn the cascading stream a milky white. To maximize sharpness throughout, I focused one-third of the way into the frame and stopped down to f/22. Then to neutralize the bluish cast of the scene, I added an 81A warming filter. With my Olympus OM-4T and my Zuiko 28mm wide-angle lens, I exposed for 1/2 sec. on Fujichrome 100 RD film.

The wide-open spaces of meadows subject them to changeable lighting conditions. When I noticed the billowy clouds in this Colorado landscape, I decided to use them as visual magnets in my composition. I set my zoom lens set at 200mm, and I compressed the key elements in the frame. As a result, the green meadow grasses provided a graphic contrast to the dark background. They also played a supporting role in terms of creating an atmosphere or ambiance. To saturate the colors in the scene, I underexposed by half a stop from a meter reading off the gray in the clouds. With my Olympus OM-4T and my Zuiko 50–250 zoom lens, I exposed for 1/30 sec. at f/16 on Fujichrome Velvia.

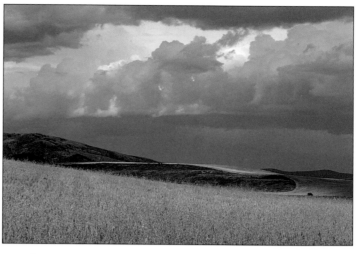

In order to enhance the textures, colors, and patterns of this meadow, I got close to the ground. Using a wide-angle lens exaggerated the foreground wildflowers, while the rest of the meadow swept into the classic backdrop of the Grand Tetons in Wyoming. I eliminated the overcast sky almost completely by tipping my camera down toward the meadow. To get the sharpest possible image in this dim illumination, I had to compromise between choosing a small aperture and a fast shutter speed. Shooting with my Olympus OM-4T and my Zuiko 28mm wide-angle lens, I settled on an exposure of f/11 for 1/15 sec. on Fujichrome 100 RD film.

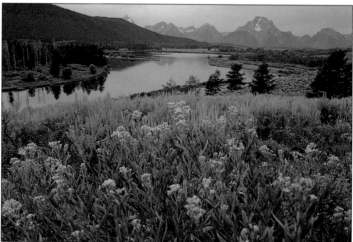

want to counteract the effects of the wind, which is a common problem when photographers work in a meadow environment, by selecting a fast shutter speed of at least 1/250 sec. However, incorporating some wind-blown grasses or flowers can actually enhance your landscape image. Try shooting the breeze by using a slow shutter speed of 1/15 sec. to 1 sec. to recreate that ideal blur. Sharpness also increases with greater depth of field, so use the smallest aperture possible. And be sure to focus with great care on the most important element: the tree or fence, or a particular group of flowers. If the scene has no special point of interest, focus one-third of the way into the frame from the bottom.

The wide-open spaces of meadows make them subject to changeable light conditions, especially on sunny days when billowy clouds dot the sky. Take a little time to notice how the changing light affects the landscape; watch which parts look best in bright light and which look best in shadow. Then frame your shot, and be sure to wait until the conditions you want reappear. Patience is essential.

In general, you should expose to saturate colors in meadows. You can accomplish this most successfully by metering the highlights on the land

and then bracketing toward underexposure. Place a polarizer on your lens in order to eliminate unwanted reflections or glare. And include only as much sky in the pictures as necessary to strengthen the images' impact. On overcast days, you may want to eliminate the sky completely by tipping your camera down toward the meadow.

MOUNTAINS AND VALLEYS

The most dramatic landscapes photographers hope to experience and record on film are those that they find in mountainous regions. But few photographers are prepared to brave the hardships that they must endure in order to reach the earth's highest peaks. Fortunately, you can find lovely mountain scenery in fairly accessible areas. Of course, you might have to hike a distance to move away from towns and other symbols of civilization, but the walk will be worth the time and effort if you find the inspiring scene you're looking for.

As you prepare for your photographic expedition, keep in mind the following pointers. Carry only as much equipment as you actually need. Consider taking only one lens, such as a 28–200mm zoom lens, which offers full compositional flexibility with a minimum of weight. A polarizer and a lens shade are musts for reducing glare. A warming filter helps you counteract atmospheric blue tones, and a UV filter cuts through high-altitude haze.

Be aware of changing light at high elevations, too. Daylight hours tend to be shorter, with sunrise taking place later and sunset earlier than they do at lower elevations on mountains. On a more positive note, look for dramatic light effects, such as early-morning alpenglow; this is the short-lived pink illumination that often bathes mountain peaks at daybreak. If you notice storm clouds moving in, use them as a dark backdrop for the sunny foreground scene. If it rains, look for rainbows, another compelling form of illumination, afterward.

Photographing wildlife in the mountains of Alaska's Denali National Park required me to set out well before sunrise. But as soon as I arrived at my destination, I spotted a small herd of moose. I had to work quickly to photograph this skittish animal before the light became too bright. Handholding a zoom lens, I framed an establishing shot of the scene, anticipating where the moose was headed. While waiting for her to get to the appointed spot, I metered the land and underexposed one full stop to bring out the russet tones. I expected to move in for closeups, but the moose got away. I made this shot with my Olympus OM-4T and my Zuiko 50–250mm zoom lens. The exposure was 1/60 sec. at f/5.6 on Fujichrome 100 RD film, which I pushed to ISO 200 for increased contrast and sharpness.

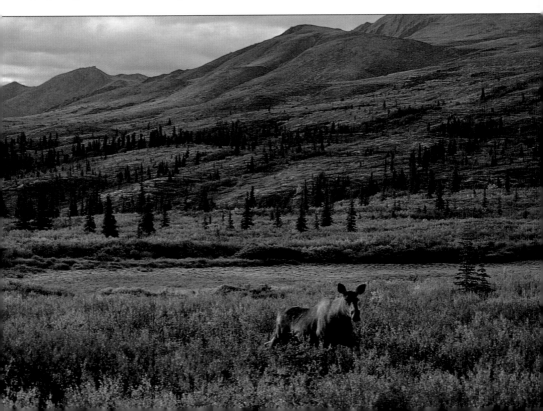

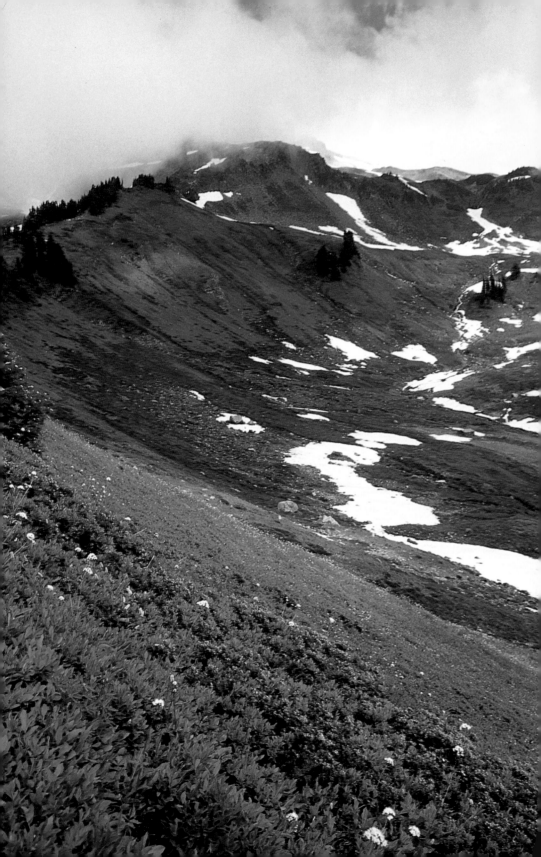

Lighting conditions can change quickly at high elevations. Hiking along the ridge of this mountain in Montana's Glacier National Park, I noticed how green the vegetation appeared when the sun went behind the drifting clouds. As I waited for the light I wanted, I set up my shot with a wide-angle lens to show the curve of the mountainside. Then I quickly metered the green and underexposed by three quarters of a stop to saturate the foreground colors. With my Olympus OM-4T and my Zuiko 35mm lens, I exposed Fujichrome 100 RD film for 1/60 sec. at f/11.

Here, I used a wide-angle lens to integrate the vineyards in the valley with the Swiss Alps in the backdrop. I framed the shot in order to have the sky show above the mountain peaks. This provided a fuller sense of the setting and outlined their shape. Using a polarizer and lens hood helped reduce glare. With my Olympus OM-2S and my Zuiko 28mm wide-angle lens, I exposed Kodachrome 64 for 1/125 sec. at f/11.

Be sure to include the sky in your composition if at all possible. The sky frames the mountain peaks and shows both their shape and outline, providing viewers with a fuller sense of the setting. Don't, however, meter the sky or even include it in a general meter reading. If you do, the resulting image is likely to be underexposed. Meter the brightest portion of the land instead.

These strategies for accurately determining exposure apply to snow scenes, too. Because of their height, mountains often remain snowcapped well past winter. If you see snow in the landscape, be careful to meter away from the snow. If the snow affects the general meter reading, the final image will be underexposed. If you can't take a spot-meter reading, simply meter your hand in the same light that envelops the landscape. This meter reading should be adequate to produce a well-exposed landscape photograph.

A tripod is essential if you are a serious photographer, but if carrying one cramps your style or seems inconvenient, you must improvise ways to hold your camera steady. You can, for example, prop it on a rock or

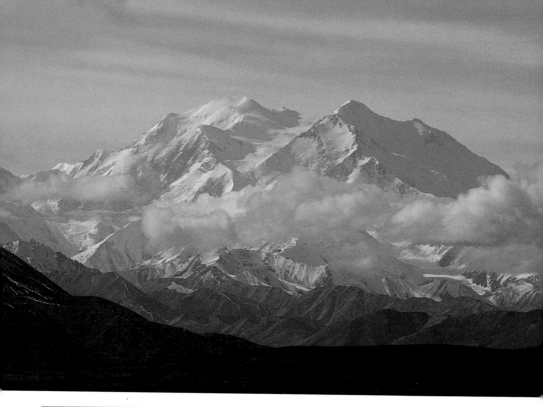

High-mountain clouds usually surround Alaska's Mount McKinley in summer. When they briefly cleared away from the summit, I worked quickly to get this shot through the window of the bus I was riding in. I placed a UV filter on my telephoto lens to cut through the high-altitude haze. While metering the gray clouds, I decided to underexpose by half a stop to darken the shadows and to provide the scene with some contrast and texture. Shooting with my Olympus OM-4T and my Zuiko 50–250mm lens set at 250mm, I exposed for 1/250 sec. at f/5.6 on Ektachrome Lumière 100.

tree stump. A poncho will protect you and your gear in case it rains—and chances are that it will in the mountains. Finally, you must keep track of time as you shoot in order to allow for your return trip before dark.

WETLANDS AND MARSHES

As natural environments, wetlands and marshes provide landscape photographers with a wealth of image-making possibilities. The most telling landscape shots find beauty in the intermingling elements of water, grasses, and sky. In addition, the waters that flow through wetlands offer opportunities for working with reflections at all times of day and in all seasons. To determine proper exposure, meter the middle tones in the landscape rather than the reflections themselves, which are brighter than their surroundings. Next, bracket toward underexposure to saturate colors. You should also check to see how your polarizer affects the image.

If you can, try photographing wetlands and marshes from a boat, so that you can get closer to the water and to the grasses of the marsh. If you're moving fairly quickly, use a fast shutter speed, at least 1/250 sec., to record your subjects. If you move in close to the grasses, use a wide-angle lens in order to encompass as much of the scene as possible.

At sunset, allow the land to become a silhouette, and try to capture the rich colors on the water and in the sky by metering the bright areas. Make sure that you don't meter the sun itself. Then shoot at the meter reading, and underexpose slightly to saturate colors more fully.

The best films to use when shooting wetlands and marshes are those that record blues and greens well. These are Fujichrome 100 RD film, Fujichrome Velvia, Ektachrome Elite, and Ektachrome Lumière. For sunset scenes or the russet shades of fall colors, select films that record warm tones well: Ektachrome 100 EPZ film, Ektachrome 64 Professional EPX film, and Fujichrome 100 RD film.

Reflections added to the beauty of this marsh landscape by intermingling the elements of water, grasses, and sky. I made this shot from a longtail boat floating on the still marsh waters in Thailand. A wide-angle lens enabled me to encompass as much of the scene as possible, both above the horizon and in the reflection. I metered the blue of the reflection through a polarizer in order to eliminate glare. Next, I underexposed by three quarters of a stop to reduce the brightness of the mirror image and to saturate colors. I experimented with the polarizer to get the exact effect I wanted in the reflection.. Shooting with my Olympus OM-4T and my Zuiko 24mm wide-angle lens, I exposed at f/8 for 1/250 sec. on Kodachrome 64.

The rich reds of sunset suffused this watery landscape of a wetland sanctuary at Ding Darling National Wildlife Refuge on Sanibel Island in southern Florida. To saturate the colors, I metered the bright areas on the water and then underexposed by one full stop. This turned the land and birds into silhouettes. With my Olympus OM-4T and my Zuiko 50–250mm zoom lens set at 70mm, I exposed for 1/30 sec. at f/5.6 on Fujichrome 100 RD film.

SEASCAPES

Anyone who has experienced the mesmerizing effects of the sea knows why photographers are drawn to it. The unobstructed views of water and sky, the beckoning horizon, and the hypnotic light give seascapes a special place in any nature photographer's landscape portfolio.

Fortunately, the techniques for shooting seascapes aren't hard to master. Build your images with light, color, and shapes. The illumination can range from dreamy to fiery, depending on the weather and time of day. Before sunrise or after sunset, the sky and water can be ablaze in rich colors, such as reds and oranges, while a stormy day reveals subtle variations of gray. In addition, clouds, coastal rocks, and distant ships become evocative shapes within an otherwise simple, natural setting.

As a rule, you should meter the sky rather than the water, which is highly reflective. Don't, however, meter the sun directly. When you photograph before sunrise and after sunset, overexpose from a general meter reading in order to include some detail and brighten colors in the final image. When you shoot at sunrise or sunset, meter the bright areas

The delicate shape of a distant boat creates a mysterious mood within a simple natural setting. I enhanced the dreamy light and soft pastel colors of this seascape off the coast of Maine by shooting three quarters of a stop below the general meter reading. With my Olympus IS-3 at its 35mm wide-angle setting, I exposed Fujichrome 100 RD film for 1/60 sec. at f/8.

The hypnotic light, the open views of water and sky, and the towering cliffs of Point Reyes in California combined to produce a magical seascape. I waited about 20 minutes after the sunset before shooting in order to capture the soft purple tones in the water and the fiery pinks in the sky. It was actually quite dark, but I metered the water and then overexposed the general meter reading by 1½ stops to get this shot. Working with my Olympus IS-3 at its 180mm telephoto setting, I exposed for 2 sec. at f/11 on Fujichrome Velvia.

A mixture of natural and constructed elements enlivened this Colorado countryside. Here, I compressed neatly spaced bales of hay with a telephoto lens, thereby adding textural interest to a smooth field. The early-morning illumination, diffused by a thin layer of clouds, softened the color palette. Shooting with my Olympus OM-4T and my Zuiko 100mm telephoto lens, I exposed for 1/15 sec. at f/16 on Fujichrome 100 RD film.

of the sky and then bracket toward underexposure to saturate colors. Avoid using a warming filter to enhance sunrise or sunset colors because this can degrade the subtle colors of the sea. And when you work under a very bright sky, underexpose half a stop from the meter reading.

If you're photographing from land, use a tripod and set the shutter speed according to the way you want to record the water. Select a slow shutter speed to blur the motion, and a fast one to freeze it. If, on the other hand, you're shooting the sea from a ship or boat, you'll find that mounting your camera on a tripod is still advisable. Keep in mind, though, that you may have a hard time maneuvering in a small vessel. The smaller the boat, the more its movements are likely to affect your image. As such, you should choose a fast shutter speed even when your camera is on a tripod.

THE COUNTRYSIDE

While the countryside isn't a purely natural environment, it offers wonderful landscape opportunities that mix natural and artificial elements. Signs of civilization include towns and villages, which are often

surrounded by fields growing in parallel rows or in patchwork arrangements. The human hand is also visible in individual farmhouses or barns, sometimes along roads that wind through the countryside. Country roads stand out particularly well in the low-angled illumination that you find early or late in the day. And fences of every kind serve to enliven countryside landscapes.

Working with colors in the country is identical to the process purely natural landscapes call for. Once again, effectively capturing the available light is the key to success. Since greens and browns tend to dominate the country scenes, be sure to show them in a dramatic way. Overcast lighting flatters many greens, while bright, low-angled sunlight complements browns. You can also intensify these colors by compressing the scene with a telephoto lens or by using films that render these colors well. The best ways to enhance the blue of the sky are by putting a polarizer on your lens and by using Fujichrome Provia and Velvia, as well as Ektachrome Lumière and Elite films. These films are excellent for rendering browns and greens, too. Pastel yellows, pinks, and mauves photograph best in uniform, diffused illumination, not bright sun.

To accurately determine exposure, meter the land. Next, you should underexpose to saturate bright colors, or overexpose somewhat to lighten pastels. If this seems confusing, meter the green area in the scene and shoot at that reading. Green has roughly the same reflectivity as an 18-percent-gray card and will be a reliable gauge even if the scene includes other colors.

To achieve maximum sharpness, mount your camera on a tripod and focus one-third of the way into your frame from the bottom. And to bring out textures in such common country subjects as bales of hay or fields of wildflowers, shoot them by early-morning and late-afternoon light. At these times of day, the long, dark shadows put textures in high relief.

Composing carefully with a wide-angle lens enabled me to combine the hallmarks of the American countryside, a solitary farmhouse along a narrow winding road, in this Vermont landscape. The overcast illumination enhanced the greens and browns that dominated the scene. Shooting with my Olympus OM-4T and my Zuiko 35mm wide-angle lens, I exposed at f/16 for 1/8 sec. on Fujichrome Velvia.

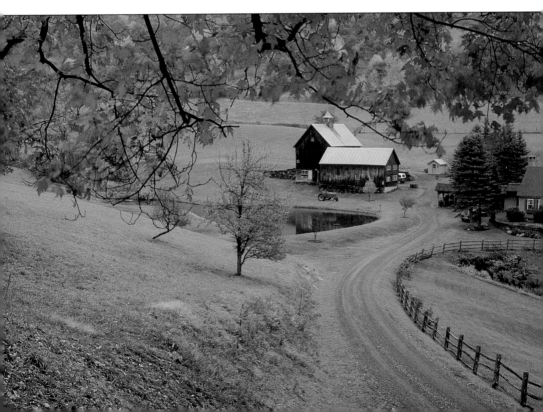

Index